The Campus History Series

OAKLAND UNIVERSITY

ON THE COVER: New Oakland University students explore and discuss their registration materials on Orientation Day. Starting with an enrollment of 570 in 1959, the young university's enrollment grew to 5,811 by the fall of 1969. Still, OU devoted significant resources to advising, especially for freshmen. The Freshman Exploratories were classes that linked individual faculty members to freshmen in groups small enough to allow for individual attention and advising. (Oakland University.)

The Campus History Series

OAKLAND UNIVERSITY

DOMINIQUE DANIEL

ARCADIA
PUBLISHING

Published by Arcadia Publishing
Charleston, South Carolina

Printed in the United States of America

Library of Congress Control Number: 2016961008

For all general information, please contact Arcadia Publishing:
Telephone 843-853-2070
Fax 843-853-0044
E-mail sales@arcadiapublishing.com
For customer service and orders:
Toll-Free 1-888-313-2665

Visit us on the Internet at www.arcadiapublishing.com

CONTENTS

ACKNOWLEDGMENTS

This book would not have been possible without the help of many individuals. I would like to thank OU Libraries archives assistant Shirley Paquette, who provided invaluable assistance in locating and selecting images as well as researching background information. Mandy Summers, manager of strategic initiatives at the OU Communications and Marketing Department, worked on the introduction and chapter six and provided vital support throughout the making of the entire book. OU Libraries technology services assistant Amy Pelkey scanned the images. Many others offered input and guidance, including Stephen Weiter, dean of the OU Libraries; Graeme Harper, dean of the Honors College; and John Young, vice president of Communications and Marketing. I thank them all for their support.

Since 1959, many photographers have helped capture Oakland University's history. Howard Coffin, one of the first students and photographers at OU, took a lot of photographs in the early years. More recently, Rick Smith has extensively photographed OU events and life since 1986. I am grateful to them and other OU photographers for their work.

Unless otherwise noted, all images appear courtesy of Oakland University.

INTRODUCTION

Like many other universities and colleges, Oakland University (OU) began at a time when the launch of *Sputnik* prompted political and popular support to expand and strengthen America's higher education and research programs. Yet, the circumstances of OU's creation are unique. This book explores the distinct character of OU through photographs illustrating central themes of its history, including people (leaders, faculty, staff, and students), the making of the physical campus, teaching and learning, an increasingly distinctive identity in a regional setting that shifted from rural to suburban, and the transformation of the university from a small liberal arts college to a metropolitan research university.

The university was developed through a gift of Alfred and Matilda G. Wilson's 1,400-acre estate, known as Meadow Brook Estate, to Michigan State University in 1957. Matilda, who had inherited a large fortune from her first husband, John Dodge, was approached by Robert Swanson, the head of the Oakland County Planning Commission, and decided to donate the estate to Michigan State, which would build a campus branch there, and to provide $2 million for the first two buildings. Thus, Michigan State University–Oakland (MSUO) became the first Michigan public university to be started with private money.

When the first academic buildings were constructed, Meadow Brook Estate was still an active farm. The campus was surrounded by dirt roads and relied on a large water tower for its water supply. The new university opened its doors to students in the fall of 1959. The first students were mostly from neighboring towns in Oakland County and were often first-generation college students; their encounter with academia generated retention challenges and required academic adjustments for the charter class.

In 1963, when the first students of the charter class graduated, the university's name was changed to Oakland University (OU), and in 1970, OU achieved full independence from Michigan State University. Until her death in 1967, Matilda Wilson remained closely involved with the life and development of OU. The young university continuously grew throughout this period, helped by the development of Oakland County. The first chancellor, Durward B. "Woody" Varner, played a decisive role in shaping the physical and curricular development of OU. His successor, Donald O'Dowd, oversaw another impressive decade of growth.

In 1984, OU celebrated its 25th anniversary and reflected on its dramatic transformation from 5,700 students in 1959 to 12,000 in 1984, from 24 faculty to 400, and from a small liberal arts college to a research university. The 1980s, however, were a time for adjustment and retooling, as the university dealt with declining college-age populations, the state's financial crisis, and student preferences shifting away from the liberal arts and toward professional fields. The university responded by relying on its values of excellence, cultural diversity, and collaboration.

Growth picked up again in the 1990s, which led to a landmark enrollment of 20,000 in the fall of 2014. New leaders strove to update the university's mission in a changing state and national context. OU built on its strengths to reach beyond Michigan in pursuit of national recognition in teaching, research, and cultural outreach. It also strove to rally alumni and donor support around its image. In 2014–2015, OU set new records for student and alumni populations, diversified its academic offerings, and dedicated new infrastructure projects.

Today, Oakland University is recognized as a student-centered doctoral research institution with a global perspective. OU engages graduate and undergraduate students in distinctive educational experiences that connect to the unique and diverse opportunities within and beyond the region. Dedicated to preparing graduates to make meaningful and substantial contributions to the workplace, society, and academia, the university is organized into eight academic units: the College of Arts and Sciences; the Schools of Business Administration, Education and Human Services, Engineering and Computer Science, Health Sciences, Medicine, and Nursing; and the Honors College.

According to the "About Oakland University" page of the school's website, OU "provides a distinct educational experience with flexible class schedules and state-of-the-art facilities, student services, classroom technologies, research labs, internships and research opportunities with corporate partners. Located in the heart of Oakland County's Automation Alley, the university has forged hundreds of partnerships with hospitals, Fortune 500 companies, cities, government agencies and educational institutions."

Currently, over 20,000 students attend classes at Oakland University each year, and the number of OU alumni has grown to more than 100,000.

Due to size limitations, this is not an exhaustive history of the university, but this volume recognizes moments in time that helped make the university what it is today. On the following pages, we invite you to relive the history of Oakland University and celebrate the milestones of this great institution.

One

THE FOUNDERS

Matilda R. Dodge Wilson and Alfred G. Wilson stand in front of their home, Meadow Brook Hall. They married in 1925 and adopted two children, Richard and Barbara, who joined Frances and Danny, the children Matilda had with her first husband, John Dodge. Alfred Wilson was a lumber businessman, and both he and Matilda were actively involved in civic, social, and charitable causes. (Meadow Brook Hall Archives.)

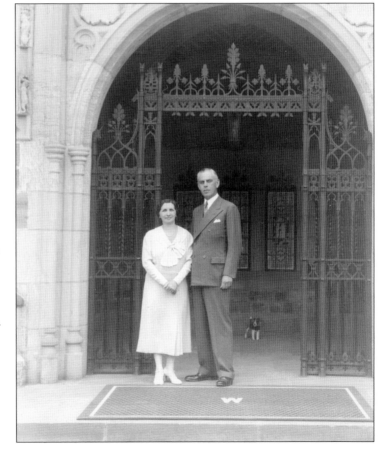

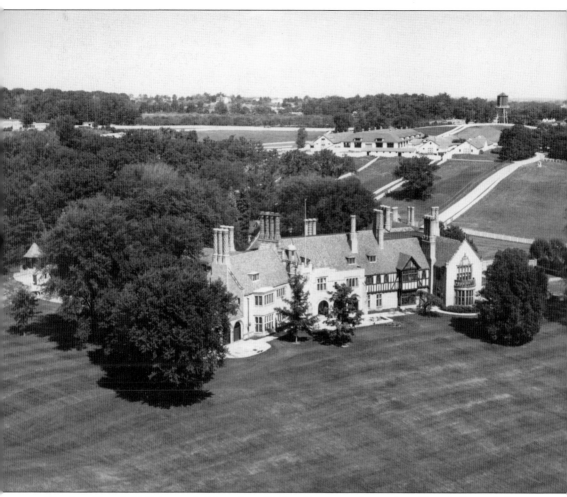

Meadow Brook Hall is nestled in a bucolic landscape with gently rolling hills and clumps of trees, white board fences, and barns. The land was originally acquired by automobile manufacturer John Dodge, who died in 1920. His widow, Matilda, married Alfred Wilson five years later, and the Wilsons started to build their Tudor Revival home, formal gardens, and farming operations. The house was completed in 1929 at a cost of nearly $4 million. On the estate, which grew to 1,400 acres, the Wilsons bred and raised Belgian draft horses, Guernsey and Holstein milk cows, and several breeds of poultry. Matilda later fondly recalled the views of cattle and horses from the residence. In 1957, she donated the estate to Michigan State University (MSU) along with $2 million to establish "a college to serve southeastern Michigan." She retained life tenancy of a portion of the property until her death in 1967. Meadow Brook Hall is now part of Oakland University (OU). (Ann Arbor Heli Photograph.)

Excluding some time during the Depression and in Alfred's later years, Matilda lived in Meadow Brook Hall from the time it was built in 1929 until her death in 1967. She was the driving force behind its design and furnishing. Today, Meadow Brook Hall is a National Historic Landmark. It is one of the finest examples of Tudor Revival architecture in the United States. (Meadow Brook Hall Archives.)

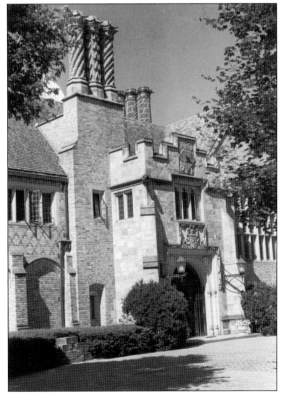

Meadow Brook Hall is an 88,000-square-foot, 110-room mansion designed by William E. Kapp of Smith, Hinchman and Grylls and constructed from 1926 to 1929. The main entrance is located in a two-story crenellated limestone structure projecting from the brick wall. The arched portal has a decorative iron gate by Oscar Bach. Above the entrance is a crest inscribed with the Wilson family motto, "Pro Legibus ac Regibus."

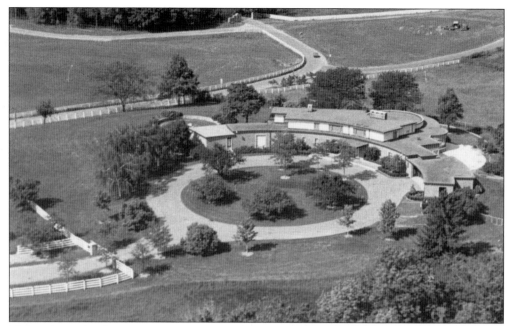

The Wilsons built Sunset Terrace in 1951–1953 as a smaller retirement home on their property. Matilda Wilson occupied the house from 1953 to 1962 and left the Terrace following her husband's death in 1962. It is designed in the style of Frank Lloyd Wright's mid-20th century work to make the most of the surrounding grounds. It later served as a residence for numerous OU presidents.

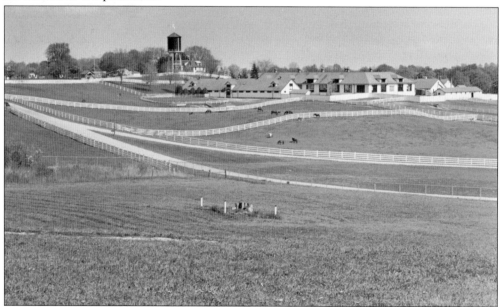

The riding ring and stables were built in 1935 by Frances Dodge. The riding ring is nearly 23,000 square feet. It is now used by the university as the Shotwell-Gustafson Pavilion. The water tower is a reminder that the estate was not connected to city water until the late 1960s; in its early years, the university relied on several towers (now demolished) and a well for its water supply.

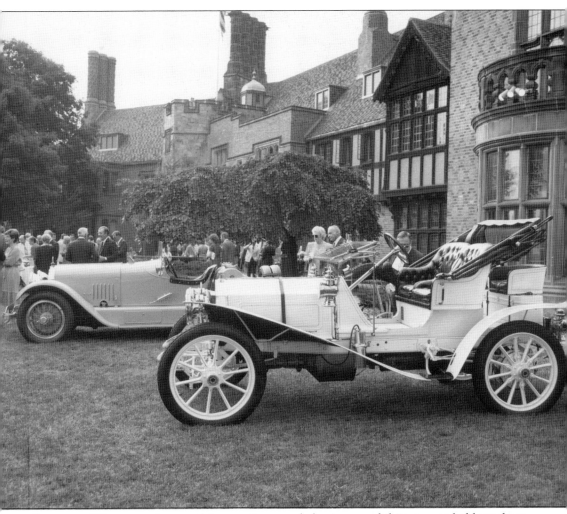

Concours d'Elegance, the prestigious antique and classic car exhibition, was held yearly at Meadow Brook Hall from 1979 to 2010. The August 5, 1984, edition shown here raised more than $60,000 to help support the preservation of the hall. That year, Chrysler Corporation chairman Lee Iacocca served as honorary chairman, and Robert E. Larivee Sr. of Group Promotions, Pontiac, served as general chairman.

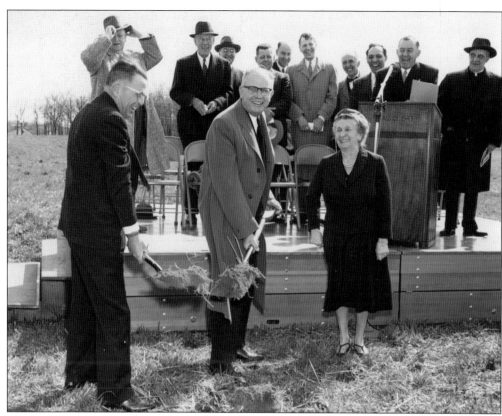

On May 9, 1958, ground was broken on the site of the university's first building. In the above photograph, from left to right are (first row) Connor D. Smith (chair of the state board of agriculture, MSU's governing body), MSU president John A. Hannah, and Matilda Wilson; (second row) state senator L. Harvey Lodge, Alfred Wilson, unidentified, Arthur K. Rouse, Durward B. "Woody" Varner, Lynn Smith, Jan B. Vanderploeg, William Baker, Harold A. Fitzgerald, and unidentified. Matilda Wilson summarized her motivations: "We believe these acres, under the wise and skilled direction of Dr. Hannah and his faculty will produce a new product—educated men and women of high standards and ideals to serve mankind." Below, Alfred Wilson and President Hannah chat after the ceremony. (Both, Michigan State University Archives and Historical Collections.)

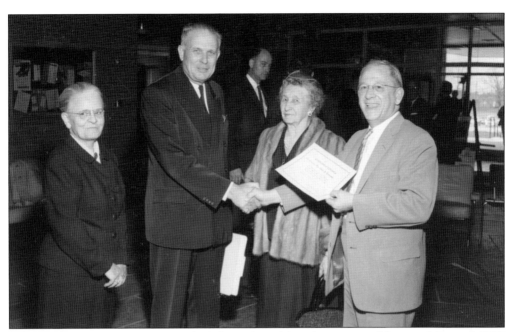

In 1957, Sarah Van Hoosen Jones (far left) and Matilda Wilson (second from right) watch MSU president John Hannah (second from left) receive a certificate from village president Sidney Q. Ennis that made Hannah an honorary citizen of the Village of Rochester. The Wilsons had just signed the transfer of the Meadow Brook Estate to the university. Van Hoosen Jones also conveyed her 365-acre home farm to MSU. (Michigan State University Archives and Historical Collections.)

D.B. "Woody" Varner was the first chancellor of Michigan State University–Oakland (MSUO), which was renamed Oakland University in 1963 after the graduation of the charter class. Varner served until 1970. Before coming to OU, he was a vice president at MSU under Pres. John Hannah, and played a key role in the planning and founding of MSU's new branch in Oakland County. Varner volunteered to become its first chancellor. As he put it, "I was a president of a university that had no students, no alumni, no faculty. Couldn't beat that for a job." In fact, he enjoyed the challenge of starting from scratch and described himself as a gardener who liked "to grow things, and the university was a great thing to grow." Throughout his tenure, Varner was popular with both faculty and students.

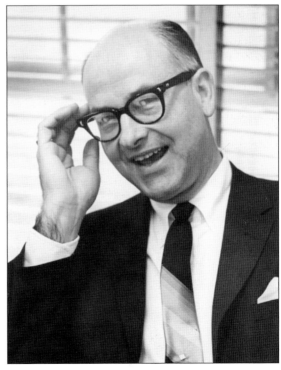

15

George Karas was the university's first employee. He was hired by Matilda Wilson in 1957 to oversee the buildings and grounds of Meadow Brook Estate and then served as director of physical plant and as university engineer until he retired in 1987. He was responsible for the development of utilities and buildings on campus.

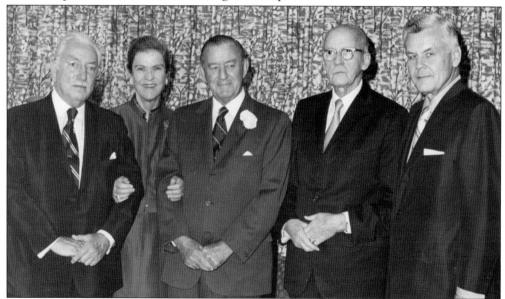

The charter members of the MSUO Foundation were, from left to right, Alfred Girard, Community National Bank of Pontiac; Elizabeth Gossett, wife of a Ford vice president; Harold Fitzgerald, publisher of the *Pontiac Press*; Donald Ahrens, former general manager of Cadillac; and Dana P. Whitmer, superintendent of Pontiac Schools. Created in 1957, the MSUO Foundation helped launch the new university. They were reunited at this 1970 dinner to honor Fitzgerald.

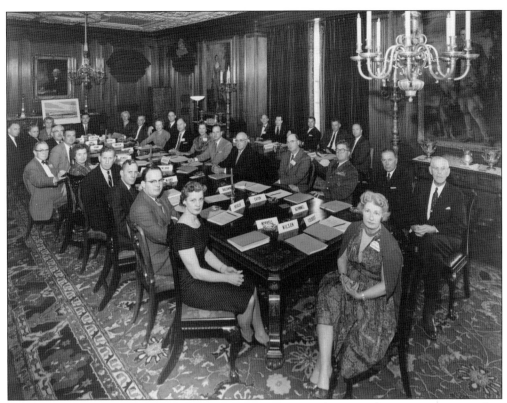

In 1958 and 1959, members of the MSU faculty, MSUO Foundation, and experts met at Meadow Brook Hall to brainstorm ideas about the curriculum. Five Meadow Brook Seminars were held to discuss business administration, education, engineering, liberal arts, and continuing education. At this April 1959 seminar, participants decided on a vigorous continuing education program based on the need for lifelong learning. (Michigan State University Archives and Historical Collections.)

The first buildings on campus were North and South Foundation Halls. MSU leaders chose the west side of Meadow Brook Estate as the best location for the academic buildings. Construction started in 1958, funded by the Wilsons' donation of $2 million, and ended in October 1959, barely in time for the first semester of classes in the fall of 1959. The buildings were named after the MSUO Foundation.

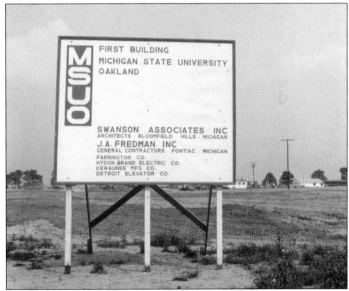

North and South Foundation Halls included 39 classrooms and two large lecture rooms, a library, laboratories, and administrative and faculty offices. The buildings were described as "no frills" functional buildings, but were well-equipped with instructional technology. Every classroom was wired to broadcast or receive televised teaching. The two buildings were originally connected by a covered walkway.

The student center (baptized the Oakland Center) was the third building erected on campus. Completed in December 1959, it included a cafeteria, student lounge spaces, meeting spaces, a game room, a bookstore, and even a barbershop. A welcome addition for commuters who needed a place to unwind and wait for their rides, it has been expanded several times.

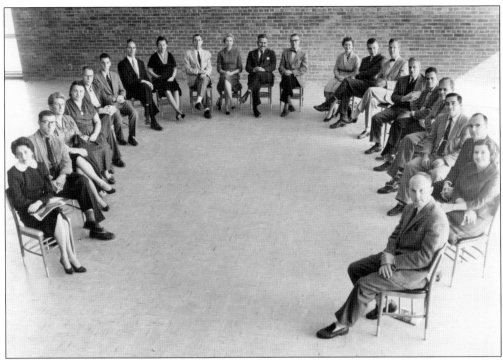

MSUO had 23 charter faculty members. They were young (the average age was 33) and highly educated, as 22 of them held PhDs from top American universities—a highly unusual fact at the time. Some of the charter faculty stayed at OU until retirement, like Paul Tomboulian (sixth from left), who earned his PhD at age 21, and George Matthews (sixth from right).

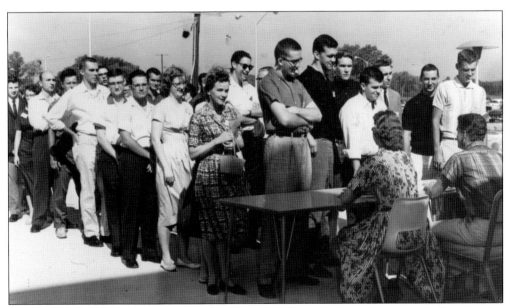

On August 24, 1959, MSUO charter class members line up at a registration desk to receive their name cards before attending an all-day orientation schedule of activities. The event was held in the breezeway between North and South Foundation Halls.

During Orientation Day, August 24, 1959, Chancellor Varner eats a boxed lunch with students in front of the new Foundation Halls. Close to 200 students were welcomed on the new campus that day. They were given tours of the building and the student center, which was then under construction. A similar program was held on August 19 with some 220 students.

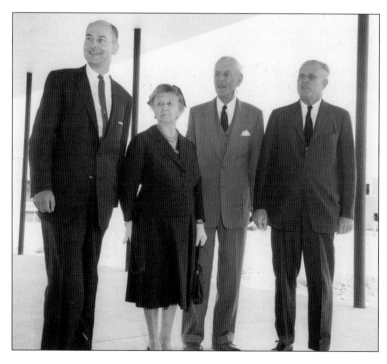

At the first freshman convocation, held on September 17, 1959, Chancellor Varner thanked the Wilsons for "a deed of generosity not often exceeded in America's educational record." From left to right are Varner, Matilda and Alfred Wilson, and Pres. John Hannah. (Michigan State University Archives and Historical Collections.)

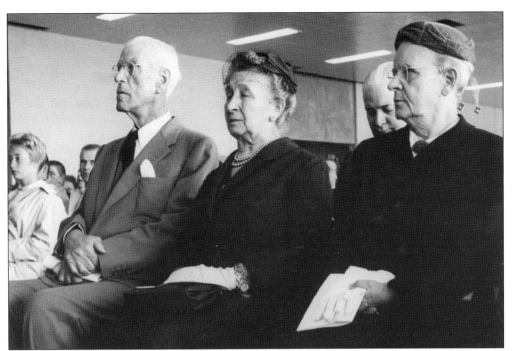

Alfred and Matilda Wilson are pictured at the first convocation on September 17, 1959. They are seated next to Sarah Van Hoosen Jones, who—like Matilda Wilson—had served on the MSU governing board and donated her farm to the university. Her estate had been in the possession of her family for more than 100 years and was situated less than five miles east of the Wilson estate. Below, from left to right, MSU and MSUO leaders were also present at the first convocation: Robert Hoopes, dean of the faculty; Chancellor Varner; John Hannah, president of MSU; and Thomas Hamilton, president of New York University and former academic vice president at MSU, who oversaw the curriculum development. (Both, Michigan State University Archives and Historical Collections.)

On Convocation Day, faculty and students process across the new campus. Chancellor Varner, President Hannah, Thomas Hamilton, and Robert Hoopes addressed the new students and faculty in the presence of MSU trustees, members of the MSUO Foundation, and members of the Michigan legislature. President Hannah declared: "Here at MSUO we are attempting to give effect to what some of the best minds in the country think is a sound revision of the definition of a good education—science, technology, and the liberal and humanistic studies in a new combination to meet the demands of today's world and tomorrow's world." Of the 570 students enrolled in September 1959, 441 of them hailed from Oakland County, and 105 of them were from Macomb County. Since there were no student residences, the vast majority of students were commuters. The students' preferred academic interest was teacher education, followed by liberal arts and engineering. (Michigan State University Archives and Historical Collections.)

Two

THE PIONEERS

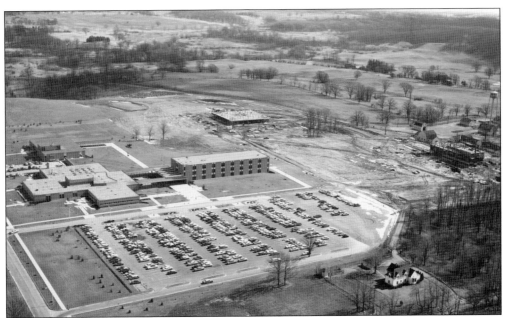

In March 1961, construction was booming on the new campus. After the Oakland Center was completed in 1959, the library and the Science and Engineering Building (the first to be funded by state money) were started. Chancellor Varner had planned a complete campus and started construction as soon as funding became available. Next would be student housing and the intramural recreational and sports building.

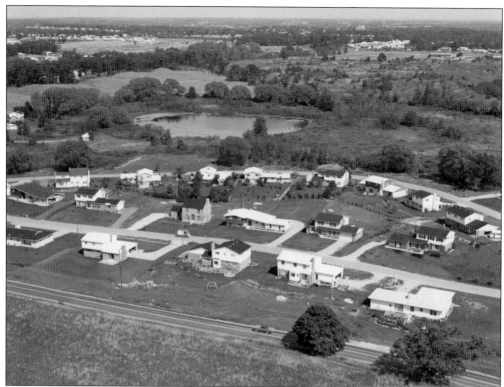

In 1959, planning began for the construction of faculty housing for professors and their families. Initially, 50 homes were built in the 150-acre subdivision east of Adams Road on land that faculty could lease. This made it easier for families of OU employees to socialize and create a community in an otherwise rural area.

MSUO leaders chose the highest point on campus as the site for the new library—the first building to be erected after the initial three structures. The site is shown here as construction got underway in October 1960. The Oakland Center is visible across what would become Library Mall.

In 1962, students of the so-called "Book Brigade" bring the library books into the new building under Chancellor Varner's careful watch. The first library was located in North Foundation Hall. The air-conditioned Kresge Library could house 200,000 volumes in its 72,000 square feet.

The courtyard between North and South Foundation Halls was a popular gathering spot for students on the burgeoning campus. North Foundation held faculty and administrative offices as well as a tiered lecture hall equipped for science demonstrations and wired for televised classes. South Foundation Hall mostly contained classrooms.

In October 1964, students Maureen Mack and Tom Miller chat in the breezeway between North and South Foundation Halls. The new Kresge Library, designed to be the focal point of campus, is visible behind them. This view of campus was frequently used for promotional brochures for the university.

Paula Varner (left), Matilda Wilson (center), and Chancellor Varner greet freshmen, including the unidentified woman at far right, at Meadow Brook Hall for freshman tea in early fall 1959. The Wilsons invited all new students and their parents to the freshman tea and made them feel at home. This was the first of many events organized by OU's benefactors for the charter class.

Known as "Pad No. 1," this former milk-processing building housed five male students in the first two years of OU. A *Detroit Free Press* article jokingly described its "luxury interior—uncarpeted wall-to-wall, steam-heated off and on." When the university opened in 1959, it had no residence halls; the few out-of-state students lived off campus in private homes and two converted farmhouses on the Meadow Brook Estate.

Twenty-eight female students lived in this home in Addison Township in the first two years of the university. Known as Upland Farms, this 600-acre property once belonged to Charles E. Wilson, a former secretary of defense and General Motors president. It was located 12 miles from campus, so students had to be bused to OU. When Hannah Hall was erected, male students moved to the top floor of the partially completed building.

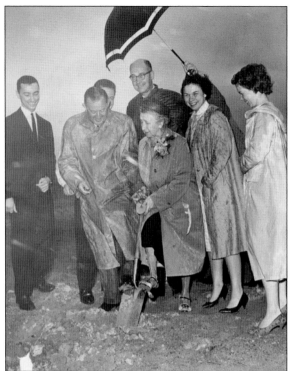

Rain did not dampen the enthusiasm of officials and students breaking ground for the first student residences in May 1961: present were, from left to right, (first row) James Reece Wolfe (a freshman), Harold Fitzgerald (MSUO Foundation member and donor), Matilda Wilson, Janet Long, and Barbara Osborne (two sophomores); (second row) Paul Allen (the student government president) and Chancellor Varner.

The first four student residences opened in the fall of 1961 on a hilly, wooded site across from the Oakland Center. They were L-shaped, cottage-type houses with 24 double rooms, intended for small-group living. One was named after Harold Fitzgerald, the MSUO Foundation member whose $45,000 gift contributed to the project.

The OU seal was designed by John Galloway, the head of the Art Department, in 1962. He chose a sail and the motto "seguir virtute e canoscenza" ("seek virtue and knowledge"), taken from Dante's *Inferno*. These were the final words of Ulysses's great speech to his men urging them to sail on in pursuit of knowledge and experience of the world.

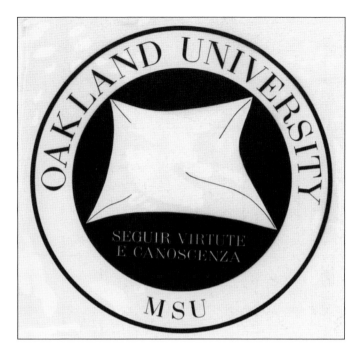

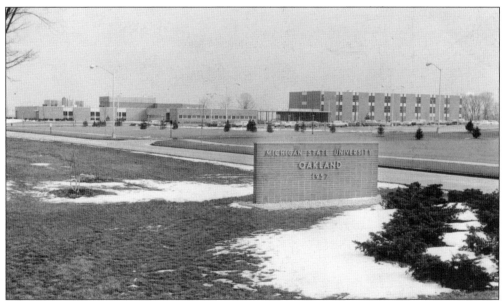

A sign bearing the university's name was dedicated on February 10, 1960. Made of brick and stainless steel, it was a gift from Pontiac-based building company J.A. Fredman. Behind the sign are the school's first three buildings: North and South Foundation Halls (front left and right) and the Oakland Center (in the background).

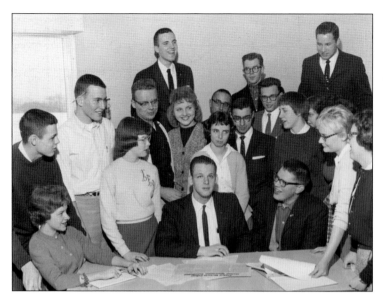

In 1959, the first academic year at OU, a student government exploratory committee was formed to determine how the students would be organized. The committee surveyed 100 colleges for inspiration.

At the end of the year, the students ratified a charter creating a student body president, senate, and executive committee, and elections were held.

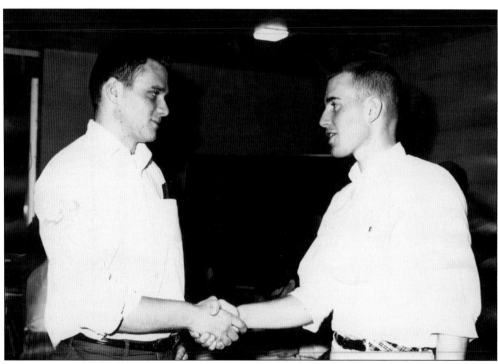

William Louis Kath (right) shakes hands with Howard Hollis Hinkel after Kath won the election for first student body president in the fall of 1960. Kath was the highest-ranking graduate in science and engineering when he graduated in 1963, and went on to become a high-ranking Ford Motor Company executive. Hinkel graduated with honors in English.

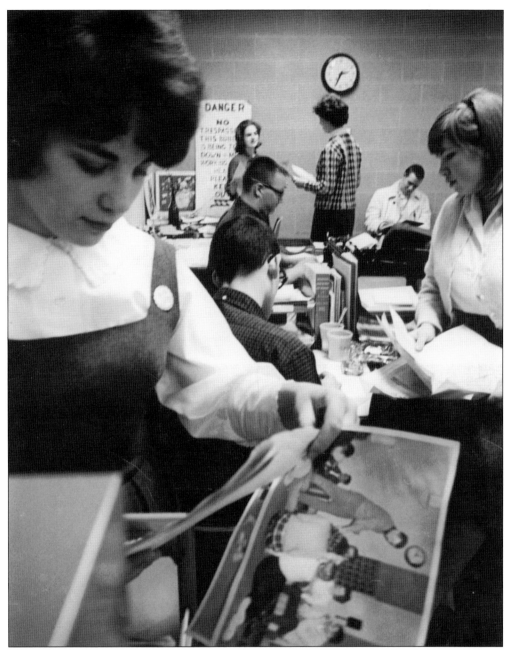

The staff of the *Oakland Observer,* the first student newspaper, is shown hard at work in the paper's office in the Oakland Center. The *Observer* started in the fall of 1959 and published its first edition on October 23 that year. A weekly student newspaper has been operating ever since under different names. Today, the *Oakland Post* is the university's student paper.

When students moved into the new dorms, social life developed on campus, although intercollegiate athletics and Greek societies were not allowed. As Chancellor Varner put it, OU did not have the "educational tailfins and chrome" of other universities. However, students could play games and attend parties on weekends. The Oakland Center had a bowling alley and table games, and after 1962, a new intramural building offered opportunities for more individual and team sports. The campus, with its fields and rolling hills, also offered ample outdoor space for fun and games. Below, students practice archery in front of South Foundation Hall on October 7, 1960. In the first few years, archery was the most popular outdoor activity. Before the intramural sports building was completed, students went to local facilities off campus for recreational and athletic activities.

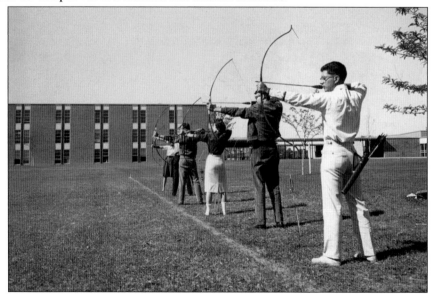

In 1959, there were three male students to every two female students, but by 1961, there were slightly fewer men than women. Joan Gibb (seated in the image at right) later recalled the cultural and social life available at OU. She had to work her way through college but benefited from the network of solidarity she found on the new campus, gaining significant psychological and financial support from faculty and staff. She and other students were responsible for organizing student clubs and their activities. Below, student organizations recruit new members in the Oakland Center at Activities Daze, an event sponsored by the Student Activities Council (SAC). The SAC hosted events and served in a leadership role for student organizations.

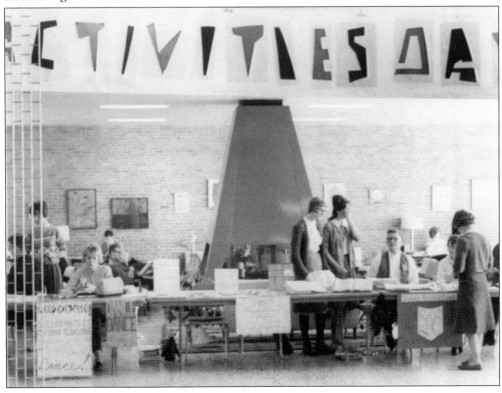

Started in 1960, the university chorus of 150 voices became the university's largest student activity thanks to Walter Collins, assistant professor of music. The chorus performed on campus, and by 1962, began performing off campus with ensembles such as the Minneapolis Symphony Orchestra and the Detroit Symphony Orchestra. There was also an octet, a dance band, a Hi-Fi Club, and a student-faculty ensemble that performed Baroque music.

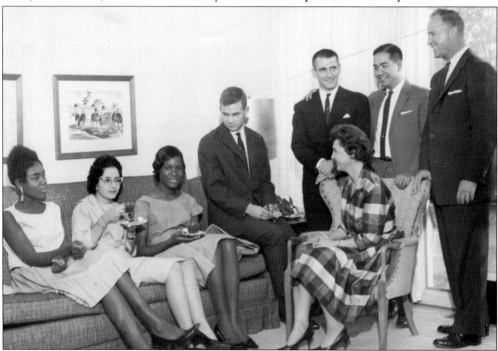

Herbert Stoutenburg (far right), director of admissions, welcomes international students to his home in October 1962. Dan Xich Lan (second from right) came from Vietnam. Stoutenburg met him in Vietnam while serving as the executive officer of the Michigan State University Vietnam advisor group in Saigon from 1956 to 1958. Lan graduated in 1963 and went on to teach Vietnamese to Vietnam-bound US Army officers in San Francisco.

34

Charlie Brown's concession stand in the Student Center was named after manager Edward Brown (left). When he came to MSUO in 1959, Brown's gruff but gentle personality and the popular song—a hit for The Coasters in 1959—came together, which led to students lovingly nicknaming him "Charlie Brown." The facility was dedicated to Brown in 1970 and remained open for several decades.

In January 1961, MSUO held its first International Festival, which featured numerous events, including an art and book display, fashion shows, movies, a seminar with foreign students, and a Cafe International offering food from many countries. Alphonse Okuku, brother of Kenya nationalist leader Tom Mboya, gave a talk. The event attracted over 1,500 people and was held again the following year.

Almost two-thirds of the charter faculty were the first generation in their families to attend college, including 9 of the 17 faculty members in the humanities. They were recruited with the understanding that they had a "clean slate" to create an innovative curriculum unconstrained by tradition. They were determined to establish an excellent liberal arts educational program at OU characterized by the promotion of critical and creative thinking.

Two-thirds of charter class students came from families with fathers who had no college education. They also had no upperclassmen to look to as models. Tuition was $255 for the year, but 60 students received scholarship aid and 45 students had loans. Students said they were surprised by the fast pace and demanding curriculum but enjoyed the faculty's friendliness and class discussions. The student population grew by 200 people each year, reaching 1,498 in the fall of 1963.

The early engineering program had a strong physics and chemistry component, as OU leaders believed that the engineering innovators of the future would have to be better educated in those fields. The program also recommended that students learn a foreign language, preferably Russian—a sign of the United States' concern with training engineers and scientists to outpace their Soviet counterparts during the Cold War.

The bookstore was located in the lower level of the Oakland Center. In the early years, it was operated by the university and saw significant traffic, since there were no other bookstores in the area. Students complained about its cramped space until it was expanded in 1969. It sold textbooks, magazines, and publications like *Oakland Undiapered*, a students' review of faculty members. The name refers to the "flying diaper," the affectionate nickname given to the university seal.

Lowell Eklund was director of continuing education starting in 1958. He organized the very first classes ever held at OU—continuing education classes held in a former poultry building on the Meadow Brook Estate—months before the official fall 1959 start. Matilda Wilson herself took the rapid reading class offered in 1958. Eklund stayed at OU until his retirement in 1988.

Loren Pope, shown here in 1961, was director of university relations and assistant to the chancellor from 1959 to 1964. His mission was to advertise the "spirit of adventure" and high-quality liberal education students could experience at OU. He had previously worked as the education editor of the *New York Times*.

In the first academic year at OU, Matilda and Alfred Wilson invited faculty and staff to a formal dinner at Meadow Brook Hall and surprised them with filet mignon from their own cattle served on gold plates. The charter faculty and their spouses often socialized with each other and with students in what became a tight-knit academic community.

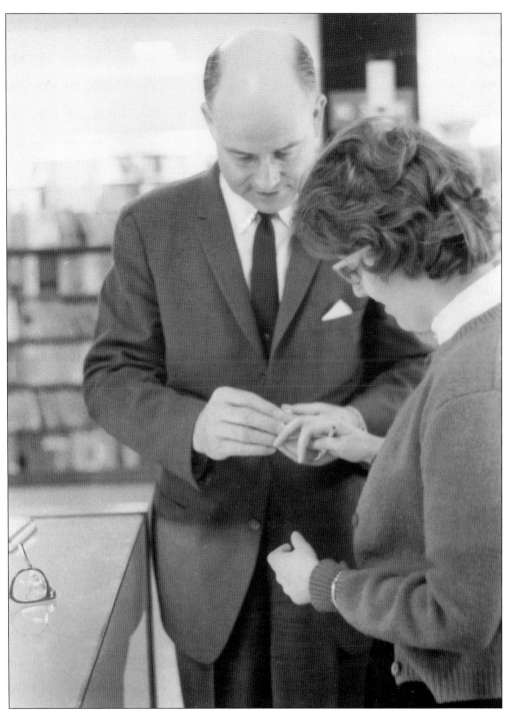

At the April 1963 senior dance organized at Meadow Brook Hall, Matilda Wilson surprised graduating students by giving each of them a gold class ring set with a diamond and bearing the legend "Oakland University Charter Class." To this day, alumni remember this generous gift fondly as a testimony to their special connection to the benefactress of OU. Chancellor Varner is seen here admiring the ring of one of the graduates.

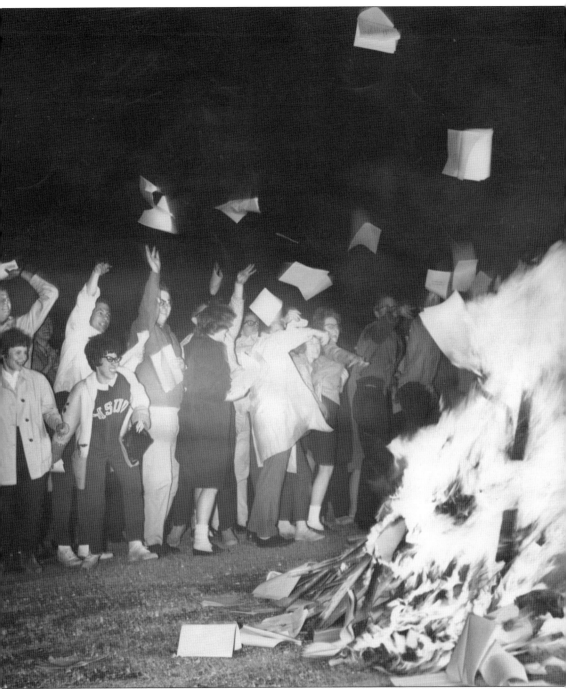

The first graduating class gleefully throw their exam books into a bonfire on April 18, 1963. Chancellor Varner and other administrators and faculty (not shown) also attended the event. In the first four years of OU, the charter class endured a demanding curriculum, high workload, and strict grading—hence their eagerness to celebrate their success. (Oakland Press.)

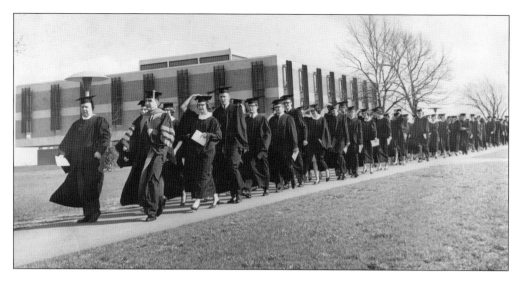

On April 20, 1963, during the first commencement ceremony, 146 students walk across campus past Kresge Library to the Lepley Recreation Center, where the ceremony took place. They received their diplomas in front of their families and the university community, including the university's benefactress Matilda Wilson, who received an honorary degree. The university had recently changed its name to "Oakland University," dropping the reference to MSU, so the new name could appear on the very first diplomas delivered to students. However, the university did not yet have an official seal—hence the unusual motif above the stage pictured below. (Below, photograph by Wooliever Studio.)

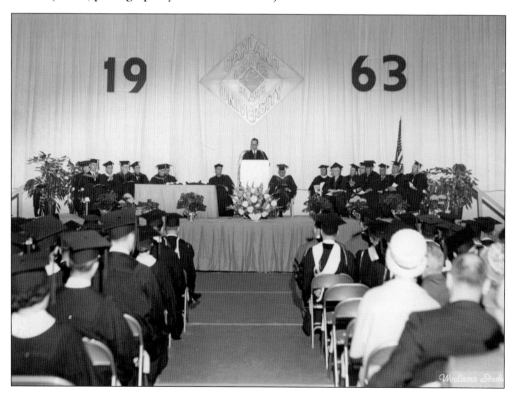

OU's very first alumni reunion on August 1, 1964, was attended by 175 people. Matilda Wilson, who had received an honorary degree in 1963, welcomed her fellow alumni with a few warm words at the Oakland Encore ceremony. Standing next to her was Lowell Eklund, associate dean of continuing education and director of alumni relations. Chancellor Varner then gave a "state of the university" address. After the ceremony, Varner and his wife, Paula, hosted the alumni at an afternoon reception on the lawn of their home, and the alumni were invited to Meadow Brook Hall for a buffet dinner. Following dinner was a Detroit Symphony Orchestra concert at the Meadow Brook Music Festival.

The first reunion participants—1963 and 1964 graduates as well as currently enrolled students—enjoyed an outdoor dinner on the terrace of Meadow Brook Hall before attending a Meadow Brook Music Festival concert featuring the Detroit Symphony Orchestra conducted by Sixten Ehrling. The entire day was blessed with perfect weather. From left to right are Thomas Henry Vos and his wife, Sharon; William Thomas Davis; Ilse Werzer; and Robert Lee Smith. OU hoped that the new OU Alumni Association would help support the university financially and morally. An alumni fund drive with a first-year goal of $2,000 was planned by the Alumni Council, presided over by James Philip Morrison ('63). It exceeded its goal with 40 percent participation. At the same time, OU pioneered an Alumni Education program aimed at helping alumni locate educational resources best suited to their needs, whether those were related to graduate study or professional training. The creation of an alumni base represented a new step in OU's coming of age. The university reached the 100,000 alumni threshold in December 2014.

Three

THE ARCHITECTS

In 1969, Chancellor D.B. Varner announced he would resign to become chancellor of the University of Nebraska. His popularity was high among OU students, who were charmed by his warmth, informality, and obvious interest in their welfare. He was so well-liked that students organized protests to ask him to stay—but to no avail. Varner resigned in February 1970.

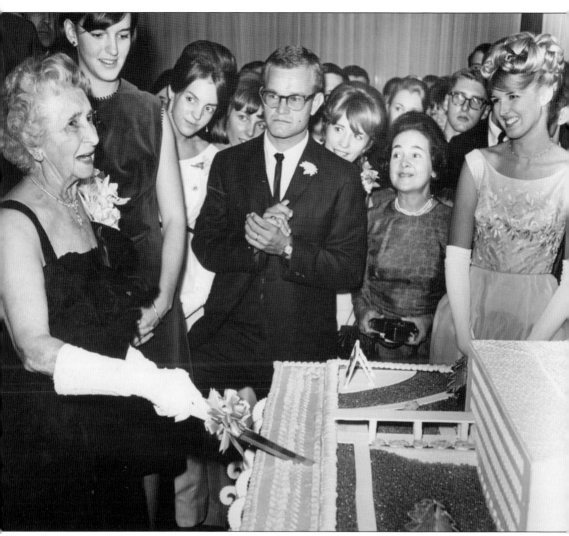

In 1965, Matilda Wilson celebrated her 82nd birthday. She is shown here at the Birthday Ball on October 22, surrounded by Oakland students and faculty, cutting a cake designed as a model of the $2.5-million Matilda R. Wilson Hall. On her actual birthday, October 19, Wilson had laid the cornerstone of the new building, which would accommodate a lecture hall seating more than 600, and an art gallery.

On November 3, 1966, OU officials and dignitaries braved the heavy snow to break ground for Dodge Hall, a new building to house the School of Engineering. From left to right are Chancellor Varner, Matilda Wilson, John Gibson (dean of the School of Engineering), and Warren Huff (chair of the MSU Board of Trustees). The building was named after automobile pioneers John and Horace Dodge, who, according to Chancellor Varner, would be "an inspiration to young men of the future who will study here and go on to become pioneers" in computer science and new scientific endeavors. John Dodge was Matilda's first husband.

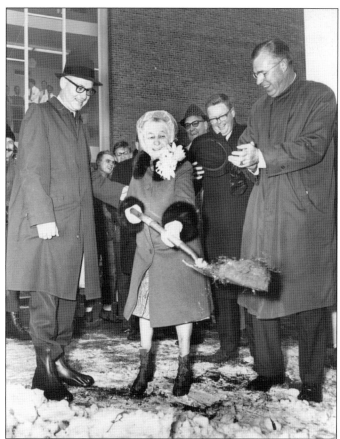

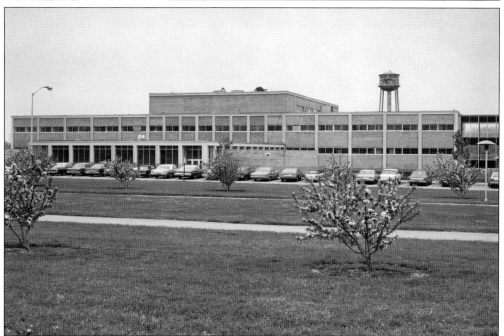

Two students walk in front of the newly completed Hill House in 1964. With six stories that could accommodate 200 undergraduate students, Hill House was much bigger and taller than the previous student residences—Anibal, Fitzgerald, and Pryale Houses. It was the first residence to include a kitchenette.

In the second half of the 1960s, OU added three additional residence halls: Hamlin Hall, the tallest and largest, came after Van Wagoner and Vandenberg Halls, with the three of them raising OU's resident capacity to 1,936. Built on a sloping hill, Hamlin Hall has its entrance on the fourth floor. It was named after Delos Hamlin, a longtime supporter of OU and chair of the Oakland County Board of Supervisors.

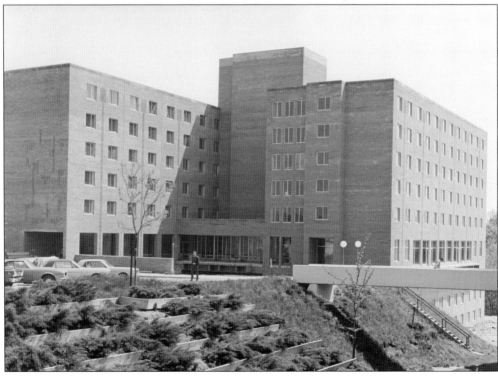

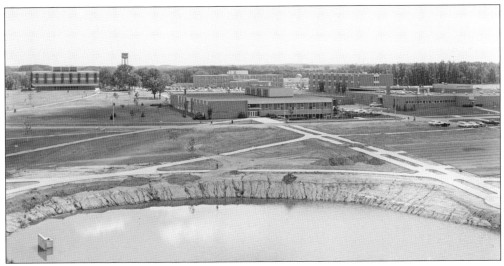

Vandenberg Hall was completed in 1966. The above photograph was taken from the new building looking south toward the Oakland Center, Foundation Halls, and Kresge Library. The new dorm had two towers for student housing connected by a central area with lounges, a cafeteria, and a kitchen. The original plans called for a four-acre lake to be formed in the depression in front of the building. During the construction period in 1965–1966, it was nothing more than a mud pit, where students enjoyed "tug-o-mud" games. Students dubbed the body of water "Beer Lake" almost immediately, and the name has stuck despite its official name, Bear Lake.

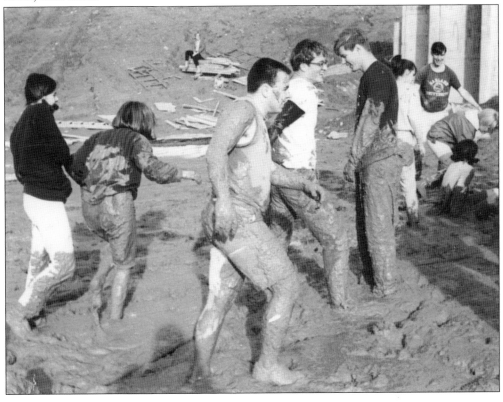

Meadow Brook Balls were held every spring from 1961 to 1965. Tickets cost $100 per couple, and the evening was an elegant social event welcoming 500 guests, as well as a major source of support for the Oakland University Scholarship Fund. Students are shown here at Meadow Brook Hall during a planning session in December 1964. Matilda Wilson continued to be a hostess for OU, even after her husband's death in 1962.

The Back Porch Majority, an American folk music group founded by Randy Sparks in 1963, performed at OU on Friday, October 28, 1966. Students gave the group's singing and comical sketches two standing ovations. They even sang "Happy Birthday" to Matilda Wilson as a special tribute, since the concert kicked off her birthday weekend.

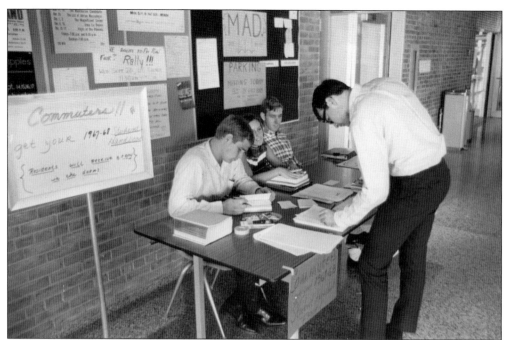

Above, from left to right, Michael Ivory, Phyllis Brown, Raye Klopfenstein, and Russel Marvin Smyth introduce the Commuter Council to OU students in the fall of 1967. The council was an elected student body with the primary function of providing a means of involving commuting students in the decision-making process of university affairs. Parking was a particularly sensitive issue for these students. That fall, 936 students voted to elect a representative to the council, the Commission on Student Life, the Student Activities Board, and the University Senate. Below, students gather in the Oakland Center to watch television. Here, residents mingled with commuters waiting for their carpooling rides.

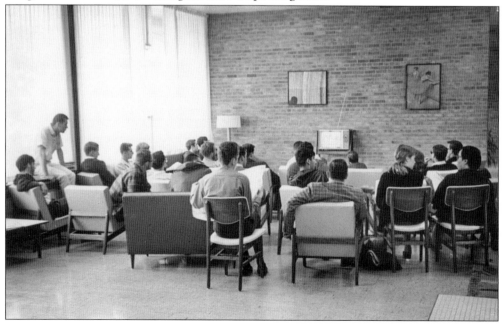

In 1967, Laurie Isenberg, an English major sponsored by the Hill House fourth floor, became Miss Oakland. The Miss Oakland Pageant was a highlight of Winter Carnival festivities at OU. Other highlights of the three-day social event held in early February included Casino Night, a snow-sculpture competition, ski meets, dog sled and skating races, and a tug-of-war on ice. It concluded with the annual Snow Ball Dance.

In 1961, a ski slope and a ski tow were set up on campus south of the intramural sports and recreation building. Use of the ski tow was limited to OU students and employees, and in the mid-1970s, season tickets cost $20. However, sledding and other risky activities were not permitted on the popular slope.

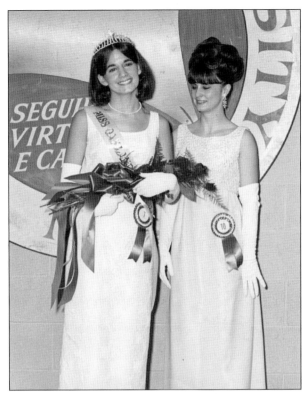

The 1966 Winter Carnival was snowless due to an unexpected thaw in early February, causing all skiing events to be cancelled. Students Donald Fielder of Detroit (left) and Harriett Slepicka of Traverse City nevertheless decided to go cross-country skiing. Kresge Library is in the background. (Oakland Press.)

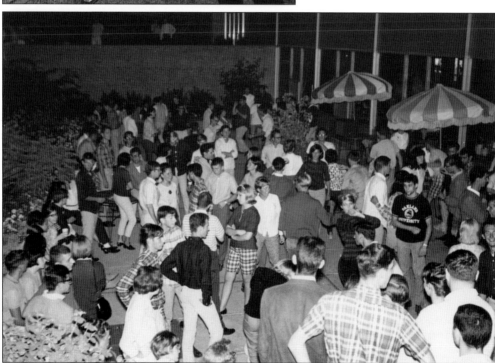

The Oakland Center hosted weekly dances for students in the 1960s, including this one held outdoors on the lower level patio. Different student clubs sponsored Wednesday night dances that featured a 25¢ admission. There were many other opportunities for dancing, including the more formal Snow Ball Dance (part of Winter Carnival) and the Chancellor's Ball.

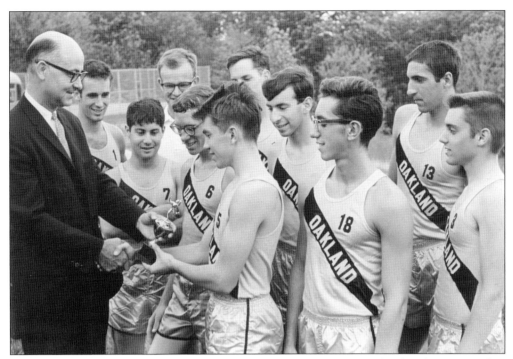

Chancellor Varner congratulates the Pioneers cross-country team for finishing second in the Tri-State Relays on September 18, 1965. Cross-country was the first intercollegiate sport after OU authorized intercollegiate sports in 1964, and the first to win a trophy. The OU team went on to win four meets that season. Louie Putnam (No. 6) and Gary Cobb (No. 5) were the lead runners.

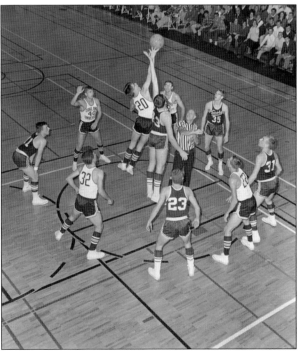

At the first game of its first season on November 25, 1966, the OU varsity basketball team defeated Alma College in front of an audience of 1,000 students. David Yennior (No. 20) is shown here leaping for the ball. OU won in spite of the elimination of its three tallest players because of their insufficient academic performance in midterms.

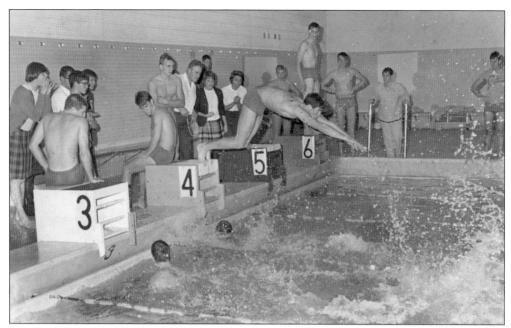

With seven wins and four losses, the OU swimming team, led by coach Corey Van Fleet, had a successful season in the winter of 1967. The highlight of the season was when Hollie Lepley stepped out in Polynesian swim trunks and swam a special "75-yard individual medley." Swimmers were the first at OU to become All-American athletes when three members made the 1969 College Division All-America Swimming Team.

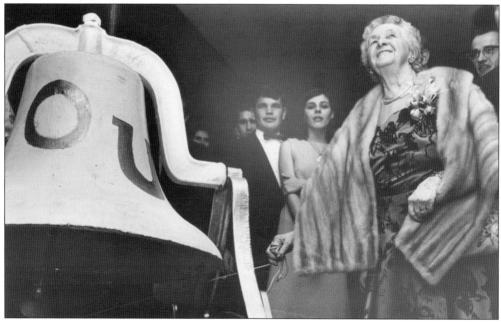

Matilda Wilson rings the MSU bell at her 81st birthday party in October 1964. The bell was "borrowed" from the Delta Upsilon fraternity at MSU, where it was used to toll football scores. It was repainted white and decorated with a gold OU seal for the occasion. The OU community celebrated Matilda Wilson's birthday every year until she passed away.

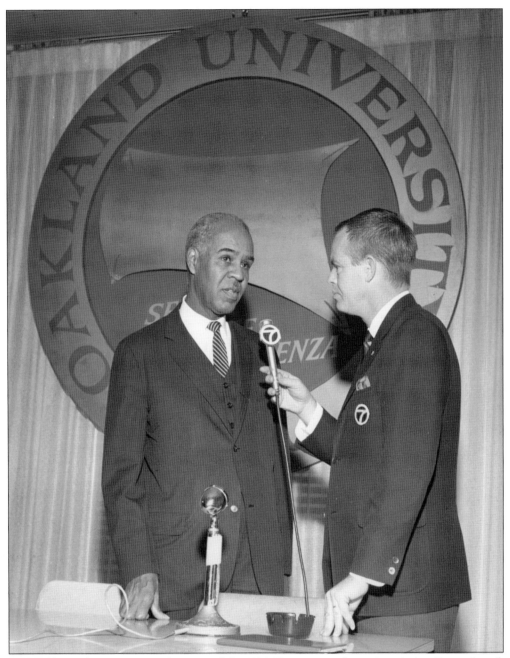

Roy Wilkins, then executive director of the NAACP, came to the university on December 6, 1966, to participate in the OU Speaker Series. He participated in seminars with students and faculty and delivered a lecture. In 1965, OU had given him an honorary degree. Here, he is being interviewed by Jim Herrington from Channel 7 Action News.

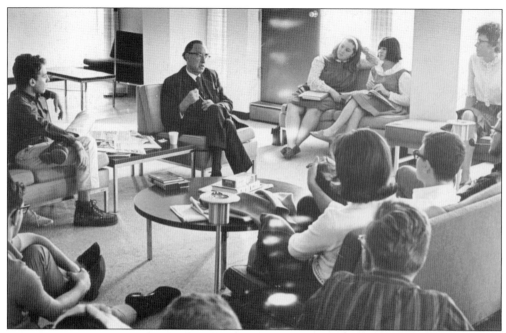

David Riesman, Harvard sociologist and author of bestselling books on American society, holds an informal discussion with students in the Hill House lounge in November 1965. Riesman was a gifted speaker, and his book *The Lonely Crowd* was used in courses at OU. Riesman went on to write a book about OU with Joseph Gusfield that analyzed the curriculum and instruction in the early years.

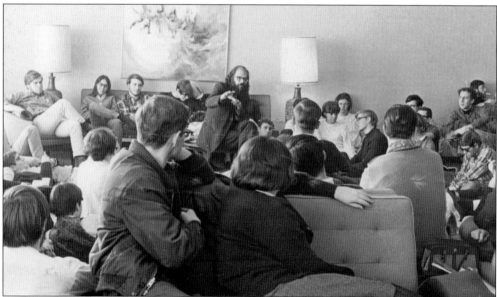

Allen Ginsberg visited OU on February 28, 1967, to read some of his *Reality Sandwiches* poems and have discussions with students. The iconic poet of the Beat Generation was a figurehead of the global youth movement in the late 1960s. The reading took place in the gym, which was lit up with candles and color wheels, and the stage was decorated with paper flowers and balloons.

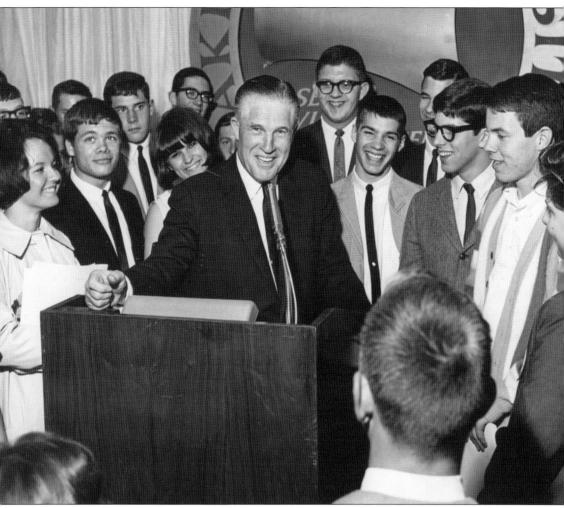

In 1965, Gov. George Romney of Michigan delivered the keynote address at the Governor's Conference on Student Leadership organized by OU. Initiated in 1963 by the continuing education division, this conference was well attended by students in part due to the popularity of Governor Romney. During his tenure as governor from 1963 to 1969, Romney attended several of these yearly conferences.

From left to right are Chancellor Varner, Robert Sargent Shriver, and Billie Sunday Farnum. Shriver received an honorary degree at the April 1966 commencement. He was the founder and director of the Peace Corps and also directed the Office of Economic Opportunity. He was the leading force behind President Johnson's War on Poverty. Farnum was a Democratic member of the House of Representatives for Michigan's 19th district in 1965–1966.

The Friends of Oakland University was created in 1963 by parents of students who wanted to make up for the lack of an alumni base. Their board of directors, elected on Parents Day, included (from left to right) Charles Stewart, James Morrison, Frank Hedge, Mrs. Grant Kurz, Dean Coffin, Mrs. James Cameron, and Walton Lewis. The Friends of OU created the Matilda R. Wilson Honor Scholarship, worth up to $1,500 per year, for an incoming freshman.

Matilda Wilson congratulates William T. Peters, one of the Matilda R. and Alfred G. Wilson Award recipients for the 1966–1967 school year. Peters and the other winner, Maureen Frances McClow, received a medallion and a $100 cash award. The annual award is given to two students who have made outstanding contributions to the life of the university through scholarship, student leadership, and expressions of responsibility in the solutions of social problems.

Project Upward Bound started at OU in 1966, welcoming 60 students. Manuel Pierson (right), a former high school teacher and counselor in Covert, Michigan, was hired as its chief counselor. Two years later, he became associate director of Upward Bound, and in 1971, he was appointed dean of student services. Special programs for minority students, like Upward Bound and Project 20, were under his responsibility until his retirement in 1993.

In 1968, the university set up the Isaac Jones Scholarship to support black students from Pontiac. It was named after OU's first black graduate, who became a social worker for Oakland County after graduation in 1965 and was shot to death two years later. At the ceremony, Robert Swanson (left) and Charlie Brown unveil a portrait of Jones.

The Kettering Magnetics Laboratory opened in 1964. Created in 1934 by the director of the General Motors Research Lab, Charles Kettering, the lab came to OU from Dayton, Ohio. The goal was to conduct experiments in gyro-magnetism, which requires cancelling the effects of the earth's magnetic field. Gifford Scott, a physicist who had been associated with the magnetics program at GM since the 1930s, was put in charge of the lab.

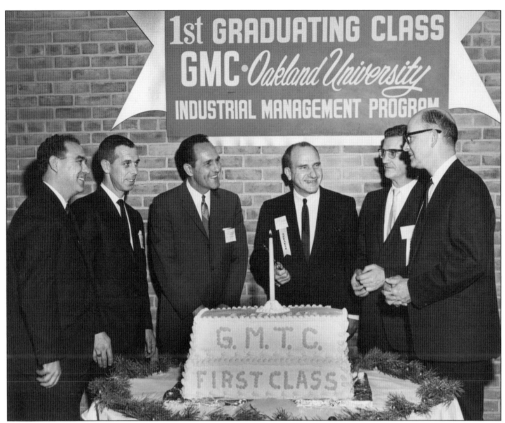

1st GRADUATING CLASS
GMC·Oakland University
INDUSTRIAL MANAGEMENT PROGRAM

G. M. T. C.
FIRST CLASS

Starting in 1966, OU partnered with the General Motors Truck and Coach Division to offer industrial management programs. Here, Chancellor Varner (far right) celebrates the graduation of the first students with Lowell Eklund, dean of continuing education (third from right), and General Motors executives in spring 1966. This was the first of many corporate partnerships at OU; these were facilitated by the geographic proximity of the automobile industry.

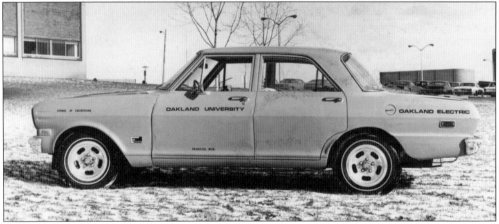

In the summer of 1970, five undergraduate students and two systems engineering graduate students built an electric car in the basement of Dodge Hall in order to participate in the Clean Air Auto Race across the continent. The OU Chevelle failed its first driving test, but the project continued thanks to two National Science Foundation grants.

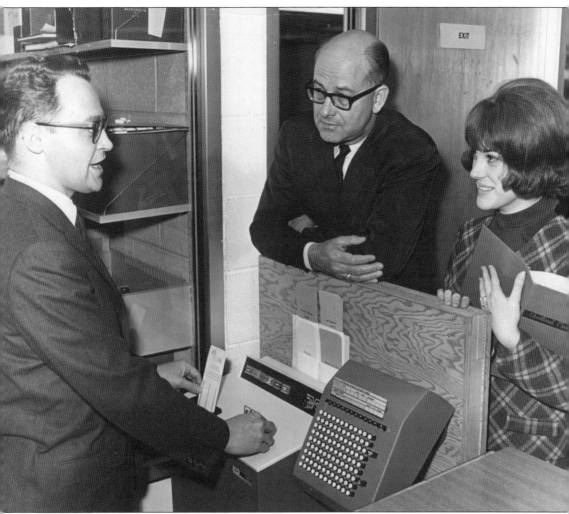

In 1966, OU librarian Floyd Cammack (left) explains the operations of Kresge Library's new computerized circulation system to Chancellor Varner and sophomore Janis McLeod. Each book was assigned a permanent, machine-readable book card, and each borrower was issued a machine-readable identification card. Both cards were inserted into an IBM 357 card reader, generating another punch card that recorded the transaction.

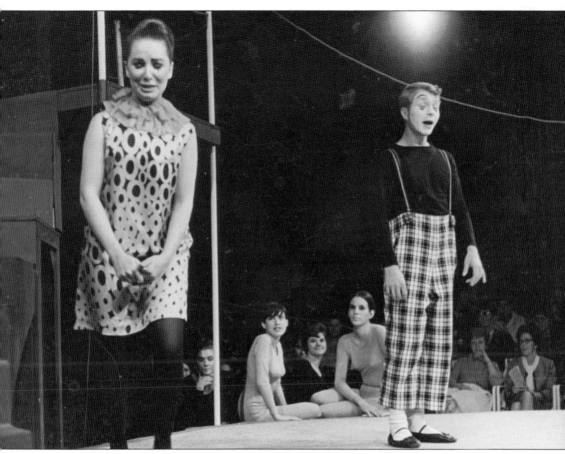

Stop the World—I Want to Get Off was the first production of the Student Enterprise Theatre (SET), which, like its predecessor, the Meadow Brook Theatre Guild, was an extracurricular dramatic group on campus. The play opened on November 3, 1967. SET gave students, faculty, and staff an opportunity to learn and enjoy acting, direction, production, set design and construction, lighting, and costuming.

At the Meadow Brook School of Music, Robert Shaw directed a 105-voice Youth Chorus comprised of students in the 11th and 12th grades (shown above) as well as a 190-voice OU Chorus. From 1965 to 1969, the Meadow Brook School of Music offered an intensive six-week summer school for high school and college students, teachers, and professional musicians concurrently with the Meadow Brook Music Festival. Detroit Symphony Orchestra members taught for-credit studio lessons to students who were selected from the United States and Canada for this innovative form of musical education. Student Paul Kirschenbaum is pictured at right adding an OU sticker to his cello case. In the meantime, the Music Department had become one of the largest at OU under the leadership of chair Walter Collins.

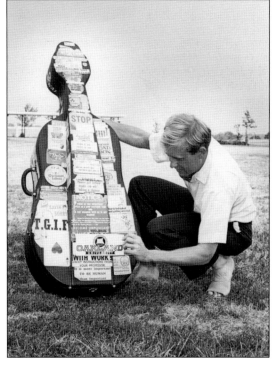

A student sings for renowned accompanist and vocal coach John Wustman in the Meadow Brook School of Music's German lieder class. Wustman, an acccompanist for soprano Elisabeth Schwartzkopf and other well-known opera singers, was a guest artist at the school in the summer of 1968. The school's guest artists taught in dormitories as well as outdoors and in other innovative locations.

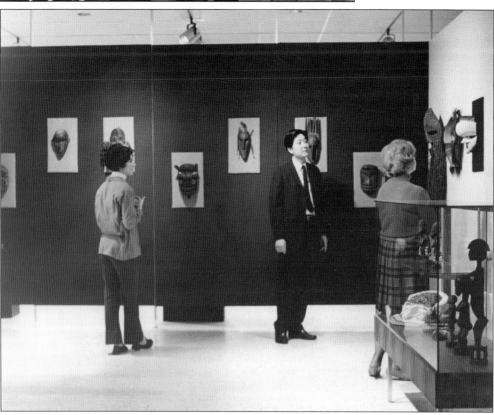

Kiischi Usui (center) was the curator of the University Art Gallery, which was originally housed in North Foundation Hall and then moved to Matilda Wilson Hall after 1966. It held regular exhibits and started developing permanent collections thanks to donations. The gallery's focus was on recent 20th century art and primitive sculptures.

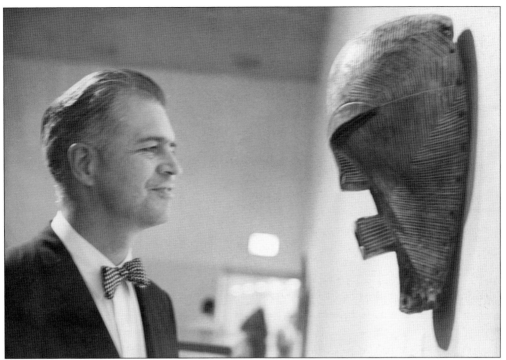

In 1968, former Michigan governor Gerhard Mennen Williams admires an African sculpture at OU's art gallery. Williams donated some 168 sculptures from West Africa to the university—part of a collection he put together during his tenure as assistant secretary of state for African affairs from 1961 to 1966. He was appointed distinguished professor at OU in the fall of 1987 but passed away a few months later. Below, Chancellor Varner (far left), George Matthews (far right, dean of the College of Arts and Sciences), and associate professor John Cameron (second from right, chair of the Art Department) listen as Williams describes one of the sculptures.

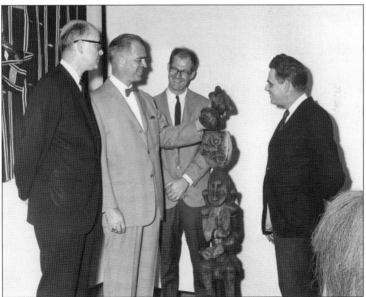

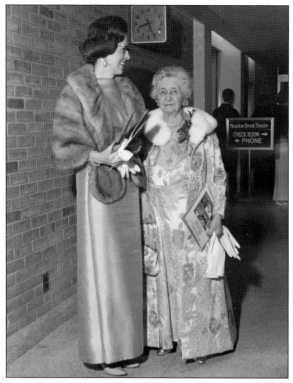

Matilda Wilson (right) and Paula Varner attend the premiere of Shakespeare's *Love's Labour's Lost* at the new Meadow Brook Theatre in February 1967. The $100-per-couple black-tie event was attended by Gov. George Romney and Detroit mayor Jerome Cavanagh and their wives. This was the first season of OU's new resident theatre company run by John Fernald, former head of England's Royal Academy of Dramatic Art, who was hired to head the Academy of Dramatic Arts on Oakland's campus. The academy was a selective two-year training program in which students studied with professionals from Meadow Brook Theatre. The theatre and academy were founded as part of OU's effort to develop performing arts in the region.

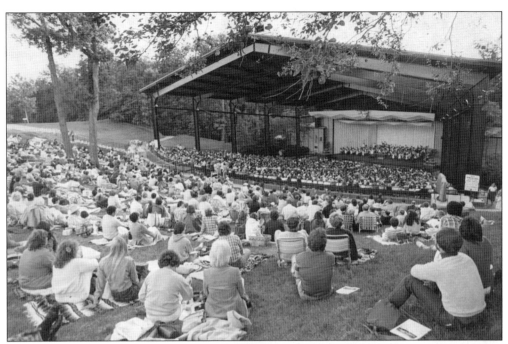

The Meadow Brook Music Festival was created by OU in 1964 to offer the public superior music in an exceptional outdoor setting. It became the summer venue of the Detroit Symphony Orchestra, directed by Sixten Ehrling, and attracted over 40,000 attendees per season. World-renowned artists performed at the festival, such as violinist Isaac Stern and pianist Claudio Arrau. James D. Hicks (at left in the image at right), former assistant manager of the Detroit Symphony Orchestra, helped Chancellor Varner (right) turn the festival into a financial and musical success along with an executive committee headed by GM vice president Semon Knudsen and his wife, Florence. The Meadow Brook Music Festival later expanded to include popular music, and to this day, the festival offers quality programs to a large crowd every summer.

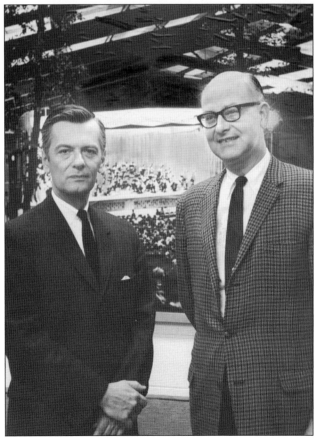

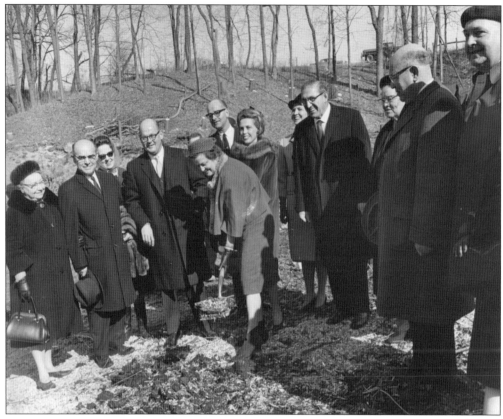

The Meadow Brook Music Festival was held in a pavilion named after Howard C. Baldwin, a trustee of the Kresge Foundation, which funded the project. On February 29, 1964, his wife hefts the first spade of earth for the pavilion to be named in memory of her husband. It was situated near the bottom of a wooded ravine at the suggestion of Meadow Brook Music Festival Committee honorary chair Matilda Wilson.

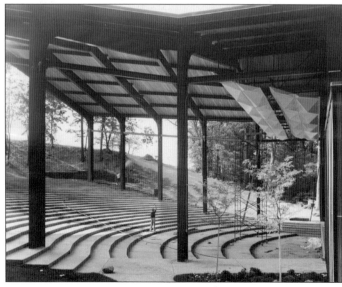

The Baldwin Pavilion was said to possess the finest acoustical setup of any outdoor sound system in the country. Its capabilities were crafted by designer and engineer Christopher Jaffe, who created its "pre-tunable sound," a flexible fiberglass concert shell able to balance and adjust the sounds of the orchestra for maximal effect.

Four

THE INNOVATORS

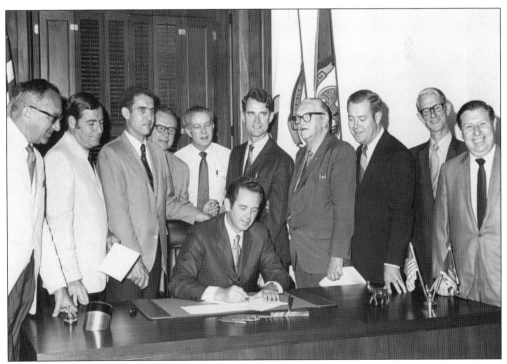

In 1970, Michigan governor William Milliken signs into law the bill giving Oakland University its official independence. Pres. Donald O'Dowd stands behind him next to other Michigan officials. Although OU had in effect run itself since the 1960s, it would now be able to establish its first board of trustees.

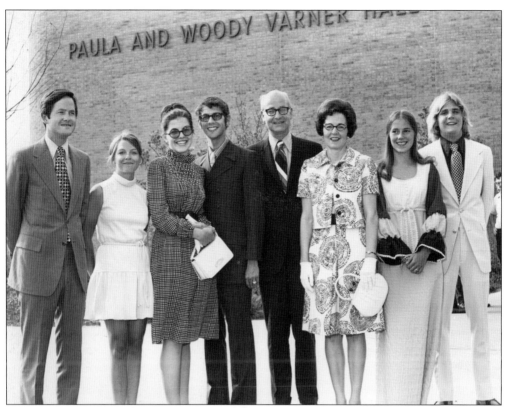

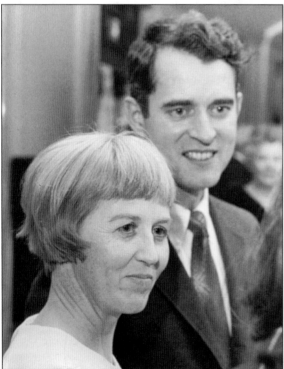

Former chancellor Durward B. Varner and his wife, Paula, (fifth and sixth from left, respectively) stand with family in front of the building named for them. The Varners returned to OU for the dedication of the building on July 9, 1971. Varner Hall provided a home for Oakland University's School of Performing Arts. It includes classrooms, practice rooms, a 485-seat recital hall, and a 200-seat experimental theater.

Donald O'Dowd (right) was a psychology professor during the early years of MSUO. He met his wife, Janet (left), while studying in Great Britain on a Fulbright scholarship. He was appointed dean of the university in 1961, provost in 1965, and eventually Oakland University's president, serving from 1970 to 1979.

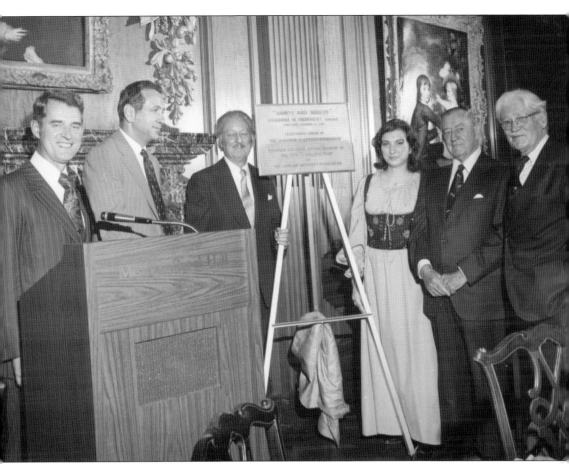

On October 22, 1976, OU officially dedicated the *Saints and Sinners* sculpture and fountain in the presence of, from left to right, Pres. Donald O'Dowd; Alan E. Schwartz, chair of the OU Board of Trustees; sculptor Marshall M. Fredericks; Mrs. David Dichiera; Harold Fitzgerald, president emeritus of the OU Foundation; and Warren Cooksey, of the Josephine Gordon Foundation. It was Cooksey, a member of OU's President's Club, who had the idea of bringing the seven statues to the university and secured funding for them. Fredericks was a world-renowned sculptor with a studio in nearby Royal Oak, Michigan. The statues were not a commissioned work. In the preceding 30 years, whenever he was not working on a commissioned work, Fredericks would turn his attention towards the figures. The bronze figures were placed at the center of a fountain and pool surrounded by polished marble in front of Library Mall.

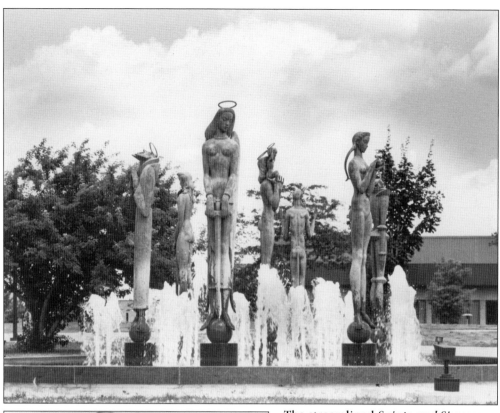

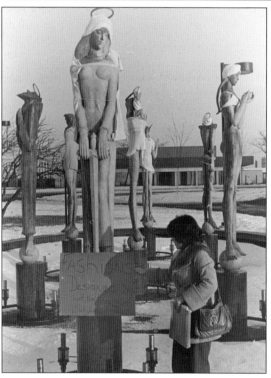

The streamlined *Saints and Sinners* figures stand approximately 10 feet tall and are made of cast bronze. Sculptor Marshall M. Fredericks insisted that in spite of their name, "these figures are very light-hearted and were designed to be humorous and pleasant with no hidden social message." Fredericks was happy to have his sculptures at OU, because he thought that the "figures are youthful—something students can relate to" and argued that it was important for a university campus to have art and humor. Students took him at his word, decorating the sculptures on many occasions. They sometimes "diapered" the sculptures—a reference to the sail-shaped seal of the university, which students humorously nicknamed the "flying diaper"—and sometimes adorned them with togas.

At the end of a decade that saw few new construction projects, OU broke ground for a new building, O'Dowd Hall, in November 1978. It was named in honor of former OU president Donald O'Dowd, who left OU at the end of 1979, and his wife, Janet. The five-story building cost $8.5 million. When it was inaugurated in 1981, it offered 102,000 square feet of classroom and office space, including several large lecture halls. It features 10-foot-long mirrored glass panels on the upper three floors. The space has been used for different departments over time, and is now home to the Oakland University William Beaumont School of Medicine.

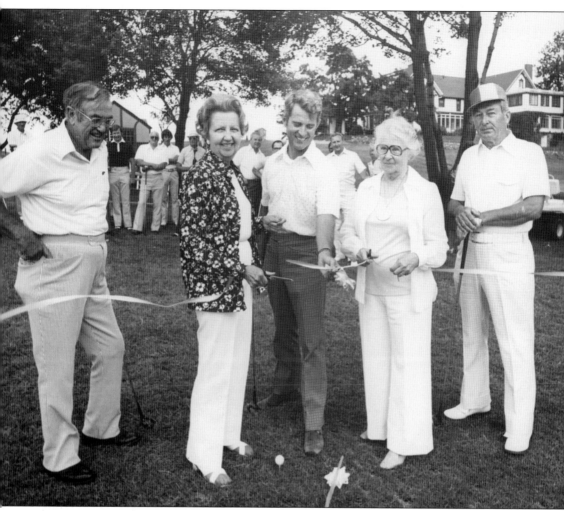

On July 16, 1976, OU's Katke-Cousins Golf Course was dedicated by its main sponsors, Harold Cousins (far left) and Marvin Katke (far right) and their spouses. Behind them is the John Dodge Farmhouse, from where John Dodge used to play his own nine-hole golf course in the early 1900s. The course opened to the public in spring 1977 when the back nine holes were completed.

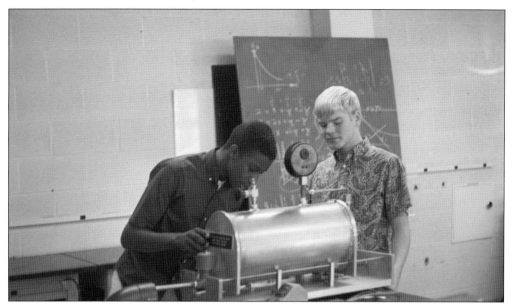

In the 1970s, the engineering program expanded dramatically at OU. Students numbered 314 in 1969 and 1,111 in 1979. The course offerings expanded as well. A turning point for OU's School of Engineering came in 1979–1980, when enrollment increased 24 percent, including 334 undergraduates in computer science and 17 graduate students. Faculty and courses were expanded, and external funding grew from $47,000 in 1977 to more than $600,000 in 1980. In 1978, OU awarded its first doctoral degrees as three engineering students completed their work. At the June 1979 School of Engineering commencement (below), four special awards were given. From left to right are commencement speaker Dr. W. Dale Compton, James Spall, Christopher Scheuer, Richard Scott, Susan Aspinall, Lawrence Stebbins, Dean Mohammed Ghausi, and Provost Frederick O'Bear.

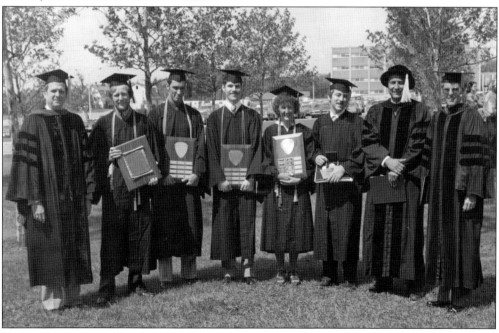

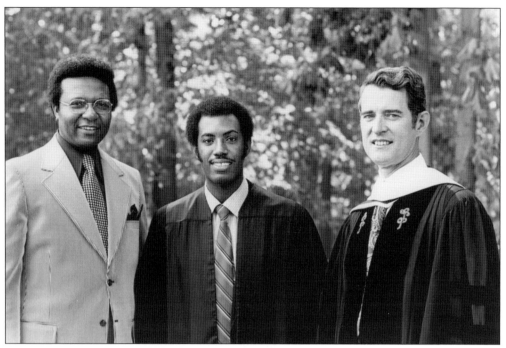

Dean of Students Manuel Pierson (left) and Pres. Donald O'Dowd (right) congratulate Earl Johnson, a history major and 1973 recipient of the Alfred G. Wilson and Matilda R. Wilson award. Since 1965, two awards are given yearly to graduating seniors for "having made outstanding contributions to the life of the university." In 1973, the other awardee was Deborah Kalcevic.

In the 1970s, OU's Division of Continuing Education managed an active program via its Conference Department, Continuum Center for Adult Counseling and Leadership Training, Course Department, Labor Education Service, and Meadow Brook Hall. The multifaceted programs were designed to help people perform more effectively as workers, parents, and citizens.

OU enrolled its first pre-nursing students (over 300 of them) in the fall of 1974 and opened its School of Nursing with 154 students and nine faculty members in the summer of 1975 under Dean Geraldene Felton—the first female dean of a school at OU. Nursing students did their clinical program at places like St. Joseph–Mercy Hospital in Pontiac, shown at right. The nursing skills laboratory (below) contained books, audiovisual materials, and equipment to support the nursing curriculum. OU celebrated the first School of Nursing graduates in December 1977. The nursing program grew quickly, and a master's degree program was created in 1980. Since 2006, a doctoral program is also offered.

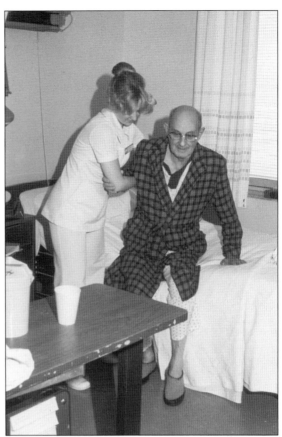

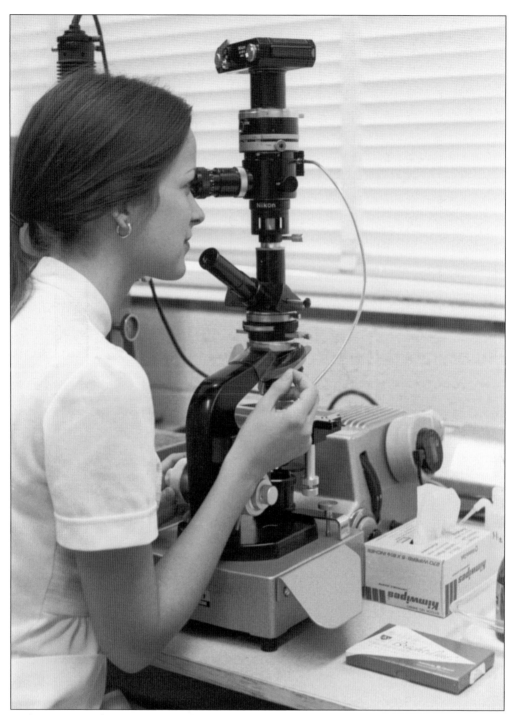

In the 1970s, students participated in advanced research in this biology laboratory where Dr. Arun Roy conducted research in biochemistry and molecular biology. Roy, a world-famous biologist, was invited to lecture on hormones and aging before a Nobel symposium in Sweden. OU set up the Center for Health Sciences in 1976 for all health-related science programs, like the bachelor's degrees in environmental health, medical physics, and medical technology.

A surge of activity in curriculum development followed the appointment of George T. Matthews as vice provost in 1972. New programs were created in medical technology and human resource development. The Honors College (below) was founded in the fall of 1977 with a capacity for 40 students during that first semester. The advantage of OU's Honors College was that it accommodated students from the professional schools as well as humanities and science students.

The Cadet Engineering program started in 1970 as part of OU's Upward Bound to help minority high school students embrace engineering. Upon completion of the ninth grade, students were brought to OU for a six-week summer session and then received support until graduation to encourage them to take science and math courses.

The Studio Company of the Academy of Dramatic Art rehearses *Twelfth Night* for a February 1970 performance. The Academy, which offered two years of intensive training in acting techniques, operated between 1967 and 1977 under the direction of John Fernald and other professionals of the Meadow Brook Theatre. The Studio Company allowed senior students to experience public performances. Students received a credit-bearing Diploma of Dramatic Art distinct from OU's curriculum.

In the fall of 1975, Student Enterprise Theatre (SET) students put on *West Side Story* at the Theatre Barn. From its inception in 1967, SET was entirely managed by students with the help of an adviser. Until 1984, SET offered dozens of plays to the campus community in the Theatre Barn before it moved to Varner Hall. Many alumni credit it for helping launch their careers in writing, theater, and television by giving them opportunities to learn about acting, set design, and production. The below image, from fall 1976, shows students preparing for a production of *Godspell*. John Roman, who later became a successful television and film producer, is standing at far right. Today, Roman produces popular television shows such as NBC's *Law and Order: Criminal Intent*.

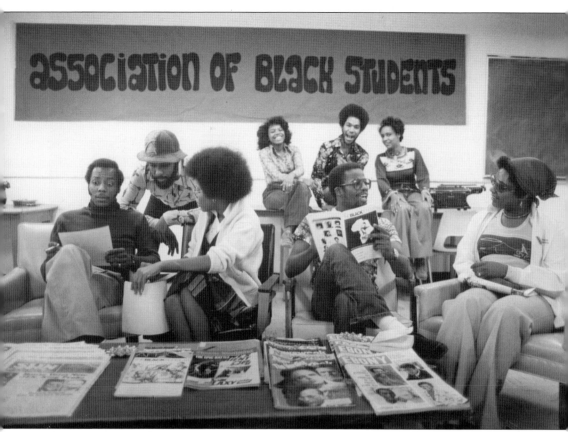

The Association of Black Students was founded in 1968 and started organizing cultural and educational programs in observance of what was then Black History Week (now African American History Month). They also supported African American students enrolled at OU and encouraged young African Americans in the Detroit area to pursue a college education at the university.

In the 1970s and early 1980s, a commuter office provided services to student commuters and helped them integrate with the university community. The Ride Pool program matched students with similar schedules and geographic locations and provided special parking for carpoolers. Carpoolers had their own parking lot, but like all members of the OU community at the time, they had to pay a yearly parking fee. The office also offered counseling, lockers, public transportation, and off-campus housing information, as well as practical support including jumper cables and other tools. The student-run Commuter Council dealt with parking problems, legal aid, and noontime entertainment on behalf of commuter students.

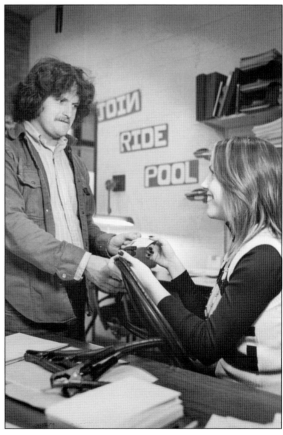

Students move into one of OU's seven dormitories in the fall of 1977. The cost to live on campus for the 1977–1978 academic year was $1,548, which included room and board. Hamlin Hall was the largest student residence and housed freshmen. Vandenberg Hall gave students the option of living on coeducational floors.

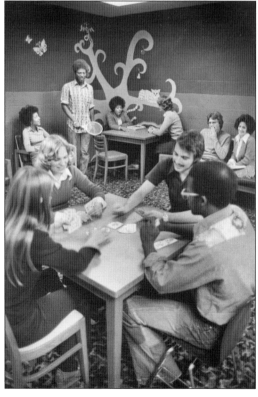

The first four dorms were the smallest units. Fitzgerald House ("Fitz" for short) was a quiet-hours building, and Anibal House housed the student cooperative. Students living in the co-op formed a unique community that worked together to maintain the building and to prepare food for most Anibal residents.

In the 1970s, Kresge Library hosted parties for the OU community following the success of a 1969 "Library I" party for the dedication of the Matilda Wilson memorial collection. At this April 15, 1972, Library II event, students, faculty, and staff enjoy live music, dancing, silent movies, poetry reading, and food spread through the different floors of the library. The folk groups The Princess and the Frog and Mike Hooper alternated playing in one of the classrooms, while the North Wind rock group and two jazz bands performed on other floors. Silent movies were shown featuring Laurel and Hardy, Mae West, and Charlie Chaplin. Around 1,600 students attended the event, which lasted from 9:00 p.m. to 1:00 a.m.

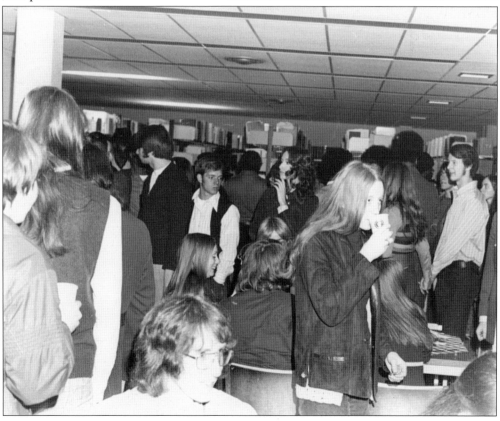

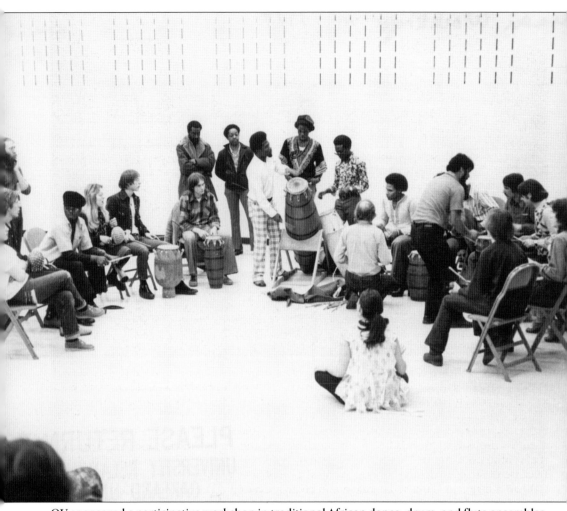

OU sponsored a participative workshop in traditional African dance, drum, and flute ensembles in March 1974. Marvin Holladay, director of the Afram Jazz Ensemble, conducted the workshops with three graduate students in Varner Recital Hall. Selected participants then performed with guest artists and OU faculty in an African music concert.

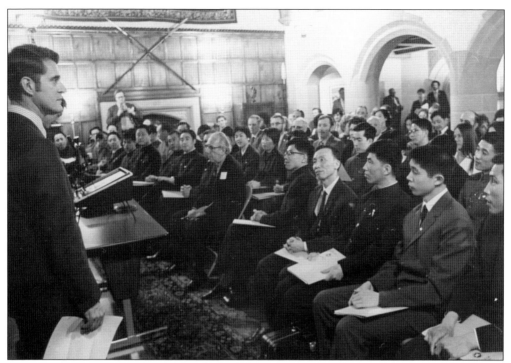

Pres. Donald O'Dowd speaks to the Chinese table tennis delegation at Meadow Brook Hall in April 1972. The delegation was feted with a reception followed by a brief ceremony with an exchange of mementos. Organizing the gathering were the cohosts for the Detroit area, the US Table Tennis Association and the Michigan Sports Hall of Fame, in concert with representatives of the United States–China Relations Committee. The committee had chosen Meadow Brook Hall for this first formal gathering in the United States. Students expressed their enthusiasm to the Chinese delegation by holding welcome signs in Chinese (below). Because of OU's curriculum in area studies, a number of Chinese faculty attended as well. OU had a major in Chinese language and civilization and concentrations in East Asia and South Asia studies.

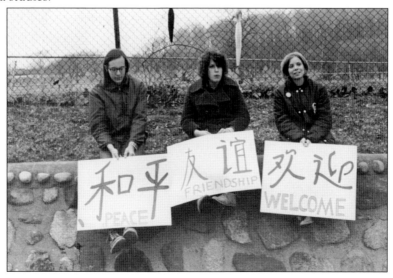

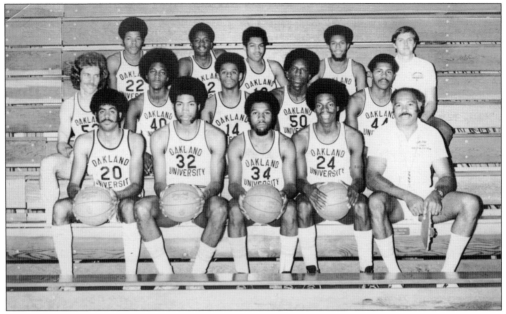

In the 1970s, OU's men's basketball team propelled OU to many victories in NCAA Division II under the leadership of coach Gene Boldon (first row, far right). Boldon was a former Wayne State University basketball star who came to OU in 1968 and helped start the men's varsity basketball team. In 1972, he also became coordinator of intercollegiate athletics.

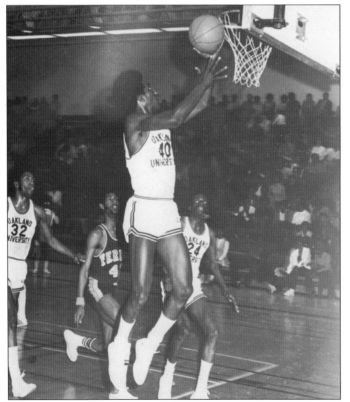

From left to right are OU players Ron Brown, Walter Johnson, and Carvin Melson. Melson, one of Oakland's outstanding basketball players, ended his career in 1973 with 2,409 points, ranking as the fourth most prolific career scorer in Michigan history. The former all-city player at Murray-Wright High School in Detroit was a sociology major.

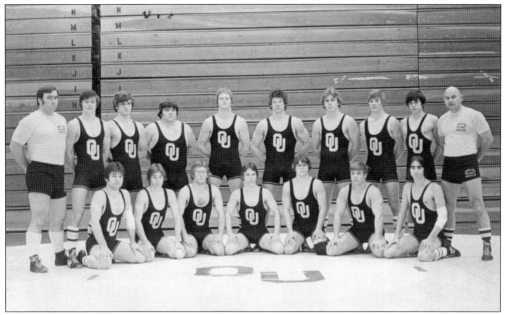

In 1976–1977, coach Max Hasse's wrestling team had a winning season, defeating the University of Dayton 47-0 in one match and also beating Adrian College and the University of Windsor. The grapplers' record was 4-3. OU had obtained full varsity status for wrestling in 1975 and started competing in the Great Lakes Intercollegiate Athletic Conference. Wrestling was dropped 10 years later.

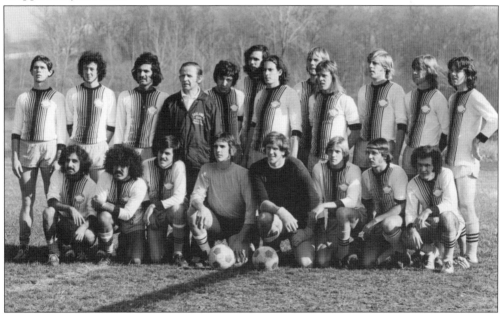

OU's men's soccer team started competing in the NCAA Division II tournament in 1973–1974 and became increasingly successful. This photograph shows the team that concluded the 1975 season with an 8-2-2 record. However, a tournament bid eluded OU that year. They earned their first tournament berth in 1976–1977 under the guidance of coach John Motzer, a former member of the Detroit Kickers.

Pres. Donald O'Dowd introduced a talking trashcan to OU volunteers at the beginning of the university's National College Pitch-In Campaign in April 1974. OU was competing for one of five $1,000 scholarship prizes offered by Budweiser and ABC Radio. OU volunteer teams, pairing a student and faculty member or administrator, helped clean up the public roads adjacent to campus.

Five

THE REFORMERS

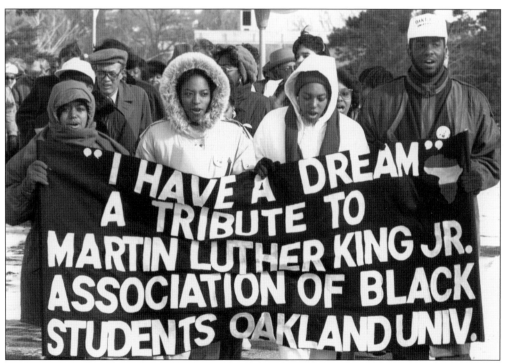

The Association of Black Students and members of the OU community march on campus on Martin Luther King Day. In the 1980s, OU started offering a full month of events for Black Awareness Month. Programs and services in support of minority students multiplied in the 1970s and 1980s, and the university created an Office for Minority Equity (now called the Center for Multicultural Initiatives) in 1993.

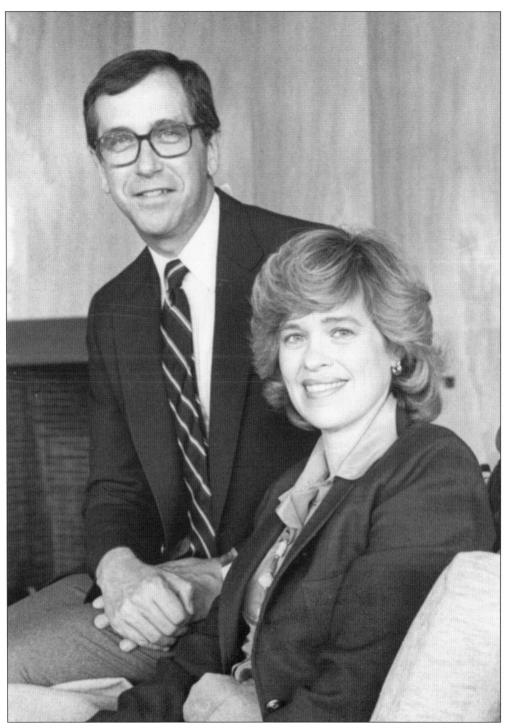

Joseph E. Champagne (with his wife, Emily) served as the third president of Oakland University from 1981 to 1991. During his tenure, the OU student body grew significantly, the Oakland Technology Park was developed, the Meadow Brook Health Enhancement Institute was inaugurated, and a number of new academic programs were approved.

In 1983, the construction of the Oakland Technology Park started as President Champagne spurred the state and developers into action. Set on 1,100 acres at the northeast corner of Interstate 75 and M-59, the park welcomed Chrysler Technology Center, Comerica, and many other corporations. The close proximity to campus made collaboration with the university easier.

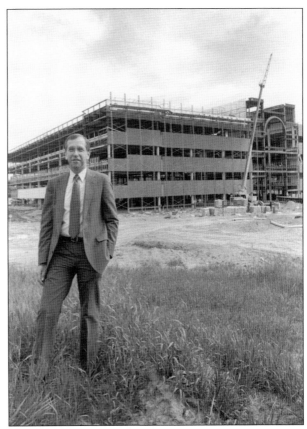

The Chrysler project, with its imposing building rising above the trees, is the largest piece of the technology park and is visible for miles. It has 2.9 million square feet inside for up to 7,200 employees. This early morning view from O'Dowd Hall shows the Chrysler building above Dodge Hall. The tech park is adjacent to the university.

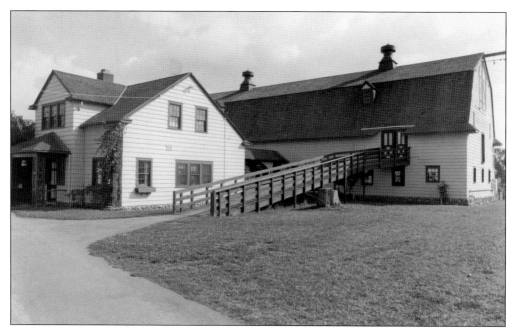

The Student Enterprise Theatre (SET) was housed in one of the old barns remaining from Meadow Brook Estate, tucked behind Hannah Hall, which had been part of the dairy building complex. It was made of knot-free oak, well known for its resonance, hand-picked by Alfred Wilson. Alumnus Tom Aston, who directed the SET productions, reported that, "during performances, you could literally feel the building vibrate with rich, clear sound." It had become a landmark on campus, although SET performances stopped in 1984 when the barn was deemed unsafe for public assembly. On August 17, 1987, the Theatre Barn was destroyed in an early morning fire (below). The ground floor was left standing but was damaged by water and smoke. Lost in the fire were 24 years of SET memorabilia. The remains of the barn were later demolished.

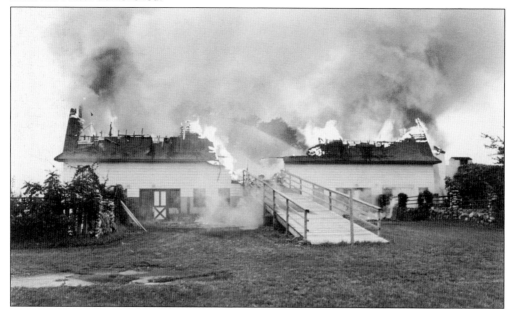

Other Things and Company was the resident company of OU's dance program, composed of scholarship students led by artistic director Carol Halsted. The unique troupe of dancers, singers, mimes, and musicians performed throughout Michigan in the 1980s, often for schoolchildren.

The Meadow Brook Estate was the Music, Theatre and Dance Department's musical theater show ensemble, which staged and choreographed its own shows. Created in 1977 with the help of a $93,000 grant from the Michigan legislature, it was open to student vocalists and instrumentalists who could experience all aspects of production, on-stage and behind the scenes, at a professional level—this was a unique program among American colleges in the 1980s.

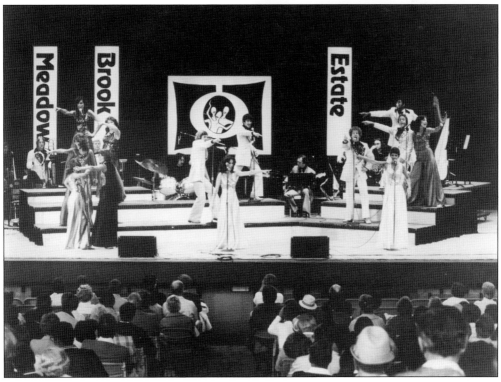

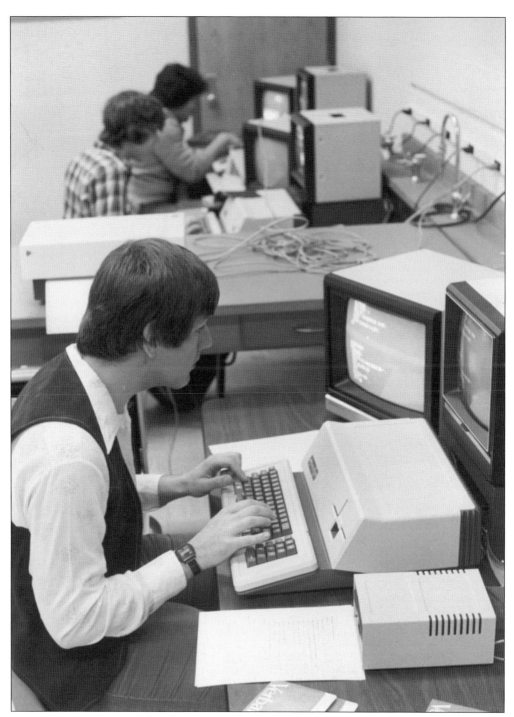

Computer science started early at OU with a Computing and Data Processing Center that opened in 1962–1963. By 1965, it already had a staff of 15, and students could take advanced courses in computer science. A concentration in computer science was oversubscribed in 1972 in its initial year, and the faculty responded by expanding the program to a major field of study for 1973–1974. A master's degree program started in 1978.

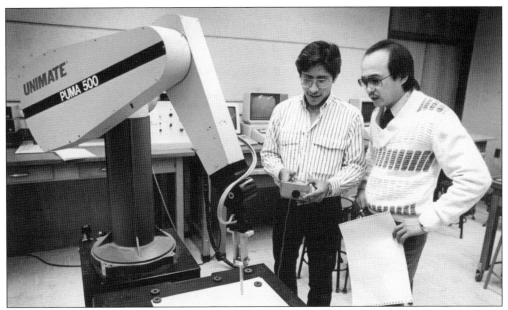

Ka Cheok, assistant professor of engineering (right), watches as a student controls a robot. High school students visited the School of Engineering and Computer Science under the auspices of the Detroit Area Pre-college Engineering Program, the successor of the Cadet Engineering program in the 1980s. Students from public schools spent six Saturdays on campus to learn about the latest in engineering techniques and equipment.

The bachelor's degree in physical therapy was first offered in the fall of 1979. Health programs grew quickly at OU under the leadership of the Center for Health Sciences' associate provost, Moon Jae Pak. In 1980, a committee investigated the possible creation of a medical school. In June 1985, in view of these developments, the center was turned into the School of Health Sciences.

The Honors College was originally housed in a single room in Varner Hall. In 1997, it moved to an addition in Vandenberg Hall. Director Brian Murphy specifically requested a facility "brilliant and modern to keep vital the intellectual life of the university" that would also physically represent honors students' growing knowledge. The modern addition contrasted with the conventional brick architecture of the student residence. Two years later, a sculpture by Joseph Wesner titled *Echo Cognitio* was inaugurated in front of the Honors College building. Its name ("the echo of knowledge" in Latin) was well suited to the Honors College, which later used it as the title of its student research journal. Pictured from left to right are unidentified; Brian Murphy, director of the Honors College; OU president Gary Russi; and Ann and Jim Nicholson. Ann Nicholson, then vice chair of the OU Board of Trustees, and her husband donated the sculpture to the Honors College.

Amit Tagore (left) was a professor of Chinese language and literature at OU from 1964 to 1987. Upon retirement, he donated his collection of Chinese art to OU, including 29 scroll paintings, 11 calligraphies, and 15 rubbing impressions of old Chinese stone monuments. In 1989, Kiichi Usui (right), the curator of the Meadow Brook Art Gallery, organized an exhibit of the art.

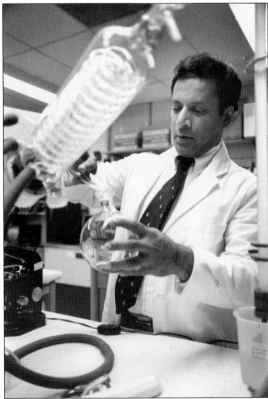

Hired as a biology professor in 1976, Virinder Moudgil used his knowledge of chemistry and endocrinology to study progesterone for 25 years. His research, which won international acclaim, involved many OU students. After 2001, he went on to serve as OU's provost for nearly 10 years. In 2012, he left to become president of Lawrence Technological University.

In the early days, Greek organizations were not allowed at OU, as they were considered detrimental to academic excellence. In 1979, however, the university recognized the national affiliation of its local fraternities and sororities. In 1980, Alpha Delta Pi was the first and only sorority on campus. By 1986, OU had 11 social fraternities, one professional fraternity, and three honor societies.

Theta Chi students sell T-shirts in the Oakland Center to raise funds for US troops during Operation Desert Storm in 1991. Theta Chi received its charter in 1981. Its members pride themselves on being heavily engaged in university activities and community service. Several presidents of the university student congress have come from their ranks.

In the 1980s, the Pioneers built upon the successes of the previous decade and shone in NCAA Division II by winning many titles in men's and women's basketball, as well as swimming and diving. Cheering spectators proudly wore OU's black, gold, and white colors, which have represented the university since its founding.

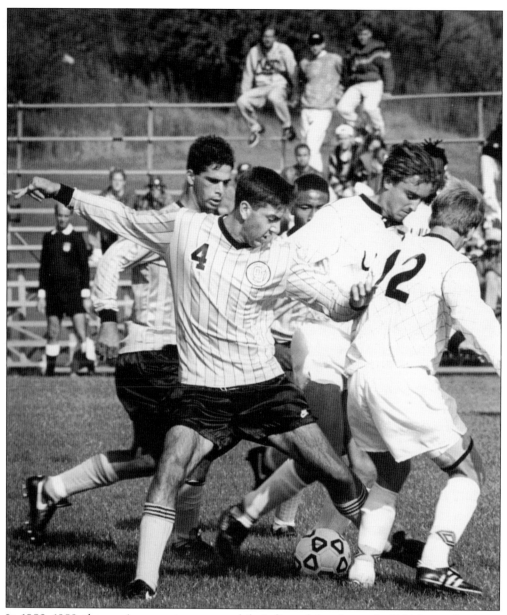

In 1982–1983, the men's soccer team earned their first of six trips to the NCAA semifinals. In 1986–1987, they advanced to the championship game, and in following years, they continued to appear in the NCAA tournament. In addition, through its soccer summer camps, OU was closely engaged with the community, and many of the camp's alumni became high school soccer coaches.

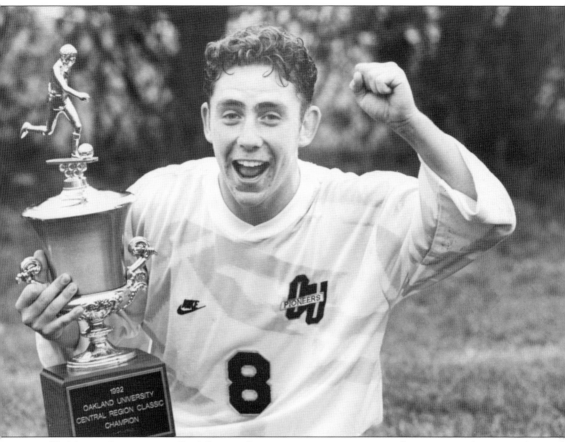

Midfielder Andrew Wagstaff celebrates the OU Pioneers soccer squad's victory in the Central Region Classic tournament in October 1992. OU won with a 1-1 tie against the University of Wisconsin–Parkside and a 5-3 triumph against the University of Northern Kentucky, a game in which the OU team scored five goals in 45 minutes.

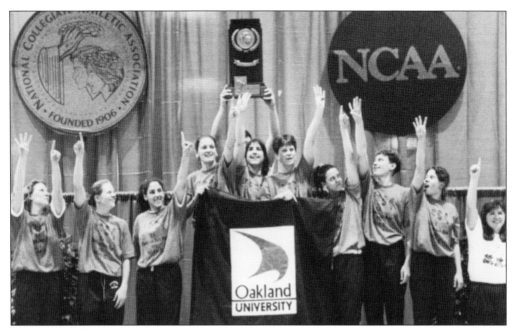

In 1989–1990, the OU women's swimming team won the first of five straight national NCAA Division II championships. Their coach, Tracy Huth, was one of the top athletes in OU history: he won 24 All-America honors and 13 Division II national titles. He became head coach of the OU women's swimming program in 1988 and led them to many victories in the following 11 years.

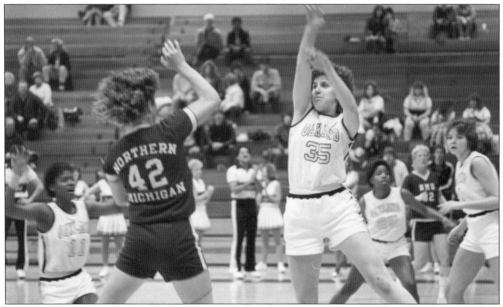

In 1981–1982, OU's women's basketball team won their first of seven Great Lakes Intercollegiate Athletic Conference championships and advanced to the NCAA Division II final four, ending up second in the final poll. Coach DeWayne Jones was named GLIAC Coach of the Year. In 1989–1990, the Lady Pioneers made their second trip to the final four and won the first round.

The Rochester Apple Amble was a five-mile road run that was part of Rochester's Art and Apples Festival. Starting in 1982, the run was included in Septemberfest, OU's series of back-to-school programs held to welcome students every September. The run through campus was a way to bring the OU and Rochester communities together.

Six sculptures stand on the eastern campus grounds near Meadow Brook Hall as a result of the Meadow Brook Invitational Outdoor Sculpture Competition organized by Kiichi Usui in 1980. Hanna Stiebel was the only female winner, with *Rhythms and Vibrations*, a sculpture that was erected thanks to funding by Mr. and Mrs. James Fitzpatrick.

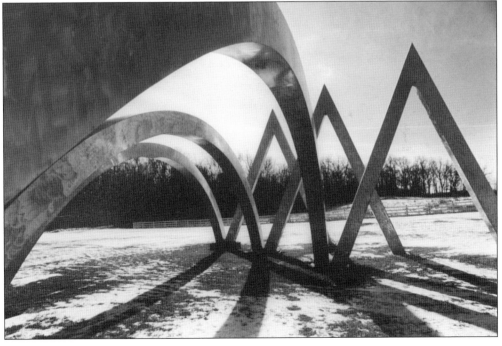

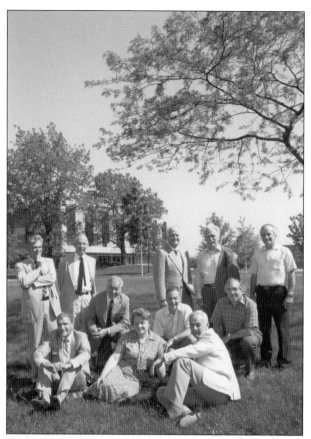

In the fall of 1984, OU celebrated its 25th anniversary. The university had come a long way since 1959, with nearly 12,000 students enrolled in 1984. Charter faculty and staff gathered for the occasion (left). From left to right are (first row) Lowell Eklund, Helen Kovach-Tarakanov, and Richard Moore; (second row) George Karas, Paul Tomboulian, and Richard Burke; (third row) George Matthews, William Schwab, Robert Swanson, Thomas Fitzsimmons, and Clare McVety. Matthews was interim president from November 1979 to February 1981. The Birthday Cake reception on September 18 (below) was followed by an open house with over 100 activities including mimes, musicians, and clowns strolling the grounds, as well as a hot air balloon festival. New Meadow Brook Seminars were organized to celebrate the 1958 seminars that helped launch the university.

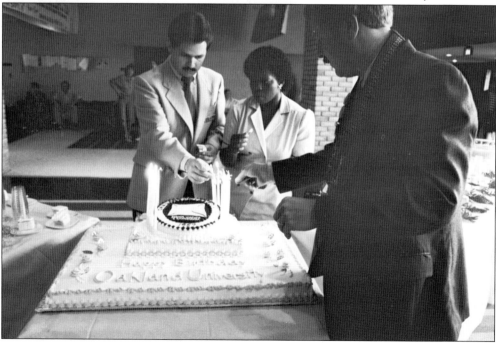

Six

THE GOLDEN GRIZZLIES

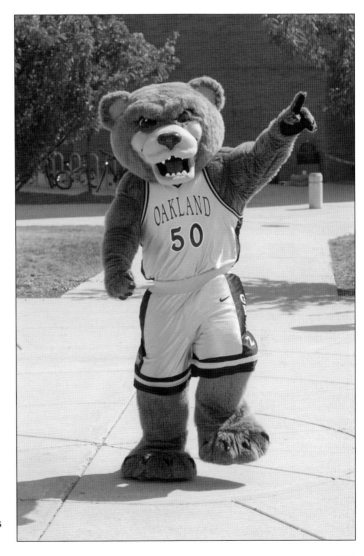

As part of OU's move to NCAA Division I competition, the new mascot, "the Grizz," made its debut at the inaugural home basketball game against Michigan State University on November 17, 1998, and OU adopted the nickname "the Golden Grizzlies." OU's previous mascot, Pioneer Pete, was then retired.

In 1991, Oakland University built on its educational commitment to Macomb County by partnering with Macomb Community College in the newly established Macomb University Center in Clinton Township. Since then, the commitment has expanded to include courses and student services offered at the OU-owned Anton/Frankel Center in downtown Mount Clemens.

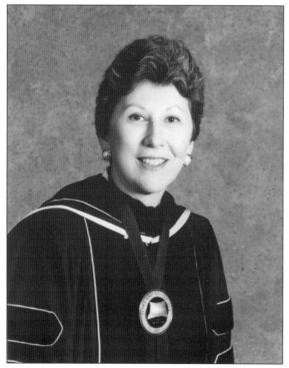

Sandra P. Packard officially took office as the fourth president of Oakland University in 1992. During her time as president, she introduced a capital improvement program, increased state funding, increased gifts and grants, introduced a School of Engineering master's degree program, received board approval of a Sports and Recreation Center concept, and created the student liaison position to the board of trustees.

Community members peruse pieces at the Meadow Brook Art Fair (MBAF). The MBAF was a juried show that included more than 175 artists. Held on the grounds of the Meadow Brook Music Festival, the event featured artists' work as well as food, entertainment, and a children's art area. The MBAF, sponsored by Creative Council (an offshoot of OU's Continuum Center), began in the mid-1970s.

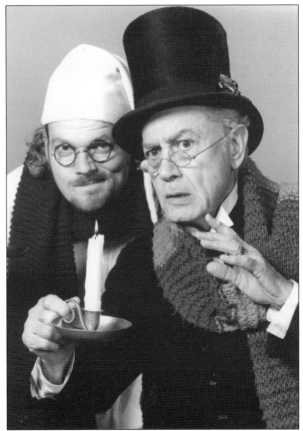

In November 1993, Joe Bailey (left) was featured as Ebenezer Scrooge in the satirical *Inspecting Carol* offered by the Department of Music, Theatre, and Dance, while Booth Colman (right) played Scrooge for the 12th consecutive year in Meadow Brook Theatre's traditional version of *A Christmas Carol*. *Inspecting Carol* is about a repertory theater that puts on the play every Christmas (very much like the Meadow Brook Theatre).

Richard Rozek (right), university marshal from 1995 through 2016, holds the university's ceremonial scepter mace. Rozek was a professor of health sciences at OU until his retirement in 2016. Oakland's mace was crafted in 1994 by jeweler and OU alumnus Paul Haig and designer Robert Dobbie of P.R. Haig Jewelers in Rochester, Michigan. The 30-inch long, approximately eight-pound mace has a white oak handle trimmed with sterling silver ribbon. A black obsidian disk on top is ringed with silver and inscribed with the university motto. On each side of the obsidian disk, there is a 14-karat yellow gold sail. The gold oak tree on the base of the handle was modeled after a live tree on campus.

In April 1996, Gary Russi was appointed the fifth president of Oakland University. Under his leadership, OU completed its first strategic plan, which paved the way for unprecedented growth and helped the university realize institutional priorities. Also during his tenure, Oakland forged numerous partnerships and alliances in Michigan and throughout the world, introduced more than 65 new academic degree programs, and oversaw many capital improvements, including the Science and Engineering Building, Recreation and Athletics Center, Human Health Building, and numerous building and facilities upgrades.

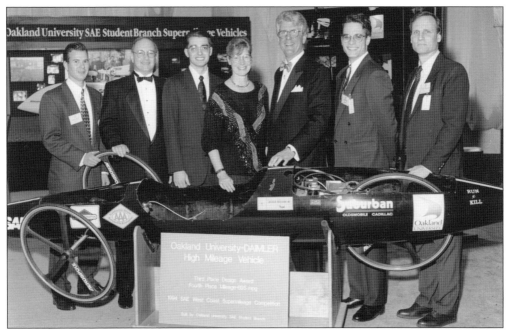

In 1994, the student branch of the Society of Automotive Engineers (SAE) at Oakland University's School of Engineering and Computer Science took third place in the design awards of the SAE West Coast Supermileage Competition with a car averaging 695 miles per gallon (pictured). Two years later, they took second place at the Midwest Supermileage Competition with a car named the *Duryea*, which averaged 876 miles per gallon.

OU's Department of Athletics received university board approval to pursue Division I-AAA status in 1997. Two years later, the university played its first official Division I season and claimed Mid-Continent Conference championships in men's and women's swimming and diving, and men's basketball.

In 1998, OU opened a state-of-the art Recreation and Athletics Center. Market research found that not only was a recreation facility a high priority for students, but the current Lepley Sports Center was not big enough to keep up with the steady enrollment growth at OU. The facility included a 50-meter pool (shared with Athletics); a three-court recreation gym for basketball, volleyball, and badminton; and a four-lane running and walking track.

In 2000, the 74,000-square foot R. Hugh and Nancy Elliott Hall officially opened with Michigan governor John Engler presiding over the ceremony. The building houses the Oakland University School of Business Administration and now includes a number of classrooms and computer labs, a business data analysis lab, and the Stinson Center. OU benefactors R. Hugh and Nancy Elliott are pictured in front of the building.

Students congregate outside of Carlotta and Dennis Pawley Hall. The hall is home to the School of Education and Human Services and the Lowry Center for Early Childhood Education, formerly housed in converted chicken coops that were once part of the Meadow Brook Estate. A ground-breaking ceremony was held for Pawley Hall in 2001, and it opened in 2002.

Pres. George W. Bush addresses a crowd of more than 4,000 at Oakland University in July 2002. He was joined in the historic visit by Pres. Aleksander Kwasniewski of Poland. The leaders came together to speak about the alliance between the two countries and their mutual vision for world peace.

After 46 years of teaching, professor of philosophy Richard Burke retired in 2005. He was the last charter faculty member at OU and was the first faculty member to be hired. In his retirement speech, Burke said, "Instead of being the low man on the totem pole, as I would have been at another job, there was no pole. Instead it was like King Arthur's round table . . . we were going to be the new wave of education. We wanted to be known as a special place."

OU president Gary Russi (right) and longtime OU benefactor Steven "Steve" Sharf celebrate OU's 50-year anniversary in 2007. A yearlong, university-wide celebration was held with numerous events marking the occasion, including a Founder's Day and Faculty Recognition Luncheon; a donor recognition gala; a student, faculty, and staff recognition dinner during Welcome Week '07; and a Meadow Brook Hall exhibition featuring newspaper articles, photographs, and other Matilda Dodge Wilson and Oakland University memorabilia.

Regina Carter, CAS '85, is a world renowned jazz violinist and a recipient of a John D. and Catherine T. MacArthur Foundation Fellowship, known as the "Genius Grant." Carter visited OU's campus while researching possible locations in Detroit for a music therapy program.

From left to right, OU president Gary Russi; OUWB founding dean Robert L. Folberg, MD; and OU senior vice president for academic affairs and provost Virinder K. Moudgil celebrate the founding of the Oakland University William Beaumont School of Medicine (OUWB). The school was formed after both OU and Beaumont recognized the negative impact that a physician shortage would have on the quality of healthcare available to the residents of Michigan. Following exploratory discussions, including discussions with community leaders, it was concluded that the combined faculty, staff, and infrastructure resources of Oakland and Beaumont would provide a remarkably strong base on which to build a new medical school and help satisfy the demand for physicians in Michigan and the nation. OUWB welcomed the first class of 50 students in August 2011.

In November 2011, Oakland University hosted a Republican presidential debate. There were many activities on campus leading up to the event, including interactive "Tech Towers" with information on each candidate, a speaker series focusing on the journalistic and logistical aspects of the debate, and business and economic forums. The debate was an unqualified success, particularly in the sense that it provided once-in-a-lifetime learning experiences for countless students, offered a valuable public service that likely inspired many to get more involved in the political process, and showcased the tremendous pool of knowledge, talent, and ambition within the university community.

Keith Benson (right) is pictured with OU men's basketball head coach Greg Kampe. Benson was the first OU basketball player to be drafted by an NBA team—the Atlanta Hawks. Coach Kampe has been with OU for 32 seasons, the third-longest tenure of any current Division I men's basketball coach.

From left to right, School of Health Sciences dean Kenneth Hightower, OU president Gary Russi, and School of Nursing dean Kerri Schuiling celebrate the grand opening of the Human Health Building in 2012. A state-of-the-art, environmentally friendly academic facility, the building serves as the primary residence of Oakland University's School of Nursing and School of Health Sciences and includes five stories of lecture, seminar, and lab-style classroom spaces designed to better facilitate academic development.

Students cross-country ski on the grounds of Meadow Brook Estate. Both the OU community and surrounding community often take advantage of the extraordinary and unique opportunities Meadow Brook Estate provides, including Meadow Brook Hall and Meadow Brook Music Festival (recently renamed Meadow Brook Amphitheatre).

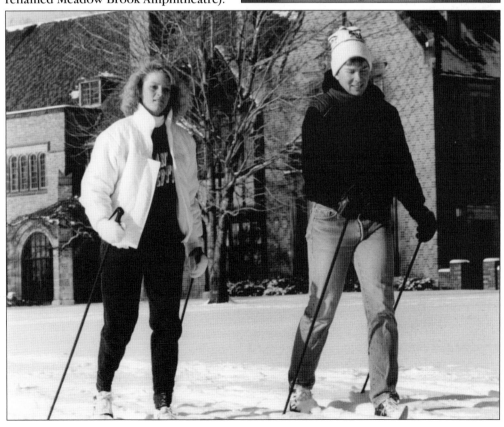

Made possible through the generosity of Hugh and Nancy Elliott, the Elliott Tower is designed to be a rallying point for student activities and creates a stunning visual centerpiece for Oakland's campus. One of the tallest bell towers on a college campus in the United States, Elliott Tower stands 151 feet tall. The tower features a fully chromatic 49-bell carillon ranging from low C, which weighs around 5,000 pounds, to high C, which weighs 24 pounds. The traditional hand-action instrument provides a complete musical range to play any musical composition. The dedication of Elliott Tower was held in September 2014.

Oak View Hall, dedicated in the fall of 2014, is a residence hall that houses 500 freshman and sophomore students and is home to the Honors College offices and classrooms, a café, and space for student meetings and studying.

Opened in the fall of 2014, the Engineering Center is the home of the School of Engineering and Computer Science. The building includes state-of-the-art instructional, research, and development space designed to foster student learning and creativity.

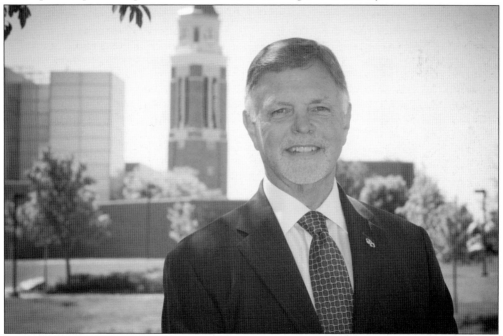

George W. Hynd was appointed the sixth president of Oakland University by the OU Board of Trustees in July 2014. During his tenure, he oversaw the completion of a comprehensive update of the university's strategic plan—a process culminating in the adoption of a revised mission statement identifying OU as a preeminent metropolitan university with a global focus. In addition, Hynd also initiated a comprehensive, campus-wide process to review and update the Oakland University Campus Master Plan using the strategic plan as a framework for facility and infrastructure planning.

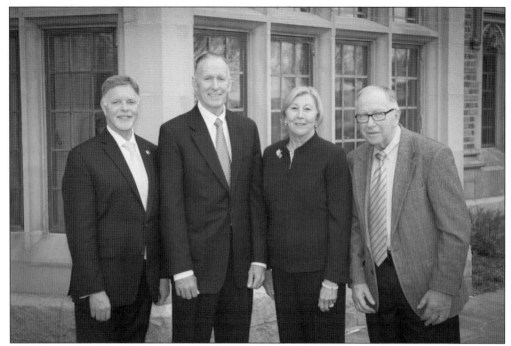

Past OU presidents gather at Meadow Brook Hall to celebrate the inauguration of George W. Hynd. From left to right are Hynd, Gary D. Russi, Sandra P. Packard, and Joseph E. Champagne.

OU student-athletes enjoy the $4.9 million, 108,000-square foot, multipurpose training facility known on campus as "the Dome." The facility allows student-athletes to train and practice year-round and features a full soccer field and baseball and softball hitting cages. In off-hours, the Dome is leased to the Total Sports Complex Company for community activities.

In 2014, OU celebrated its inaugural Fall Homecoming celebration. The weekend provided plenty of Golden Grizzlies spirit, fun, and laughs as OU students, faculty, staff, alumni, retirees, and friends gathered for a weekend of family-friendly campus events and activities. Prior to 2014, homecoming was celebrated as Winter Homecoming and held in the early part of the year, typically in February.

Patricia A. Dolly, senior advisor to the president on diversity, equity, and inclusion, speaks at the inaugural Diversity, Equity, and Inclusion Conference held at Oakland University in 2013. The conference reinforces OU's commitment to creating and supporting a diverse, equitable, and inclusive environment for all community members as well as those visiting the campus. Diversity, equity, and inclusion objectives are grounded in the realization that one cannot build a foundation of collaboration while focusing on differences between contributors. Instead, the foundation must be built on the shared aspirations, commitments, and surmountable challenges of all.

From the fall of 2000 to the fall of 2015, Oakland University saw record enrollment growth every year—a 16-year growth streak. During this time, GPA and ACT scores of incoming classes also continued to climb. A large part of the enrollment growth was due to transfer students. Currently, more than 40 percent of the total undergraduate population are transfer students, making OU one of the top transfer destinations in the state of Michigan.

The Oakland University William Beaumont School of Medicine graduated its first class of students in May 2015. Students are pictured walking through campus for the inaugural commencement ceremony.

Gregory Patterson, associate professor of dance and dance program director in the Music, Theatre, and Dance Department, has been teaching at OU for 21 years. Patterson is the founder and artistic director of Patterson Rhythm Pace, a jazz-based dance company that strives to bring professional jazz dance to the Midwest region. He has been dancing professionally for more than 30 years, during which time he has been a member of Harbinger Dance Company, Eisenhower Dance, Ann Arbor Dance Works, and Rigmarole Dance Company. Patterson has also performed as a guest artist with both the Bill T. Jones/Arnie Zane Dance Company and the Doug Elkins Dance Company from New York.

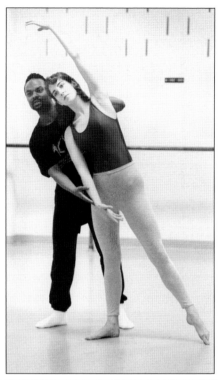

The Eisenhower Dance Ensemble performs at OU. A dance company in residence at OU, the Eisenhower Dance Ensemble has rehearsed, performed, taught workshops, and choreographed in collaboration with the OU dance program since its inception in 1991. Advanced OU student dancers often have opportunities to perform with the professional company.

DISCOVER THOUSANDS OF LOCAL HISTORY BOOKS
FEATURING MILLIONS OF VINTAGE IMAGES

Arcadia Publishing, the leading local history publisher in the United States, is committed to making history accessible and meaningful through publishing books that celebrate and preserve the heritage of America's people and places.

Find more books like this at
www.arcadiapublishing.com

Search for your hometown history, your old stomping grounds, and even your favorite sports team.